LANCE OUT LOUD

PAT LOUD

EDITOR
CHRISTOPHER MAKOS

Glitterati
INCORPORATED

New York | London

First published in 2012 by

New York Office
225 Central Park West
New York, New York 10022
Telephone: 212 362 9119
media@glitteratiIncorporated.com

London Office
1 Rona Road
London NW3 2HY
Tel/Fax +44 (0) 207 267 9739
cfagg@glitteratiincorporated.com

glitteratiIncorporated.com

First edition, 2012

Library of Congress Cataloging-in-Publication
data is available from the publisher.

Hardcover edition ISBN 13: 978-0-9832702-6-3
Editor Christopher Makos
Art Director Pau Garcia

makostudio.com
paugarcia.net

Printed and bound in China
10 9 8 7 6 5 4 3 2 1

For Lance. Pat Loud
For Hollywood. Christopher Makos

Acknowledgments

Ellis Amburn, Don Bachardy, Doug Brinkman, Ben Brown, Robby Cavolina, Christian Capobianco, Rod Denault, Danny Fields, Craig Fisse, Faith Flam, Annie Flanders, Victoria Galvez, Don C. Hanover, III, Bob Hofler, Kristian Hoffman, David Keeps, Victoria Looseleaf, Kevin, Grant, Delilah, Michele and Bill Loud, Bobby Mayhem, James Moore, The Mumps, Taylor Negron, Lisa Jane Persky, Bryan Rabin, Joe Reegan, Rob Scheiffele, Kevin Scott, Rocky Schenk, Ann Summa, Debbie Trent, Cherry Vanilla, Rufus Wainwright, Andy Warhol, Patty and Jim Werner, Paul Zone.

With special thanks to Christopher Makos, whose genius put this whole thing together and Marta Hallett for believing in it enough to make it happen. Pat Loud

Contents

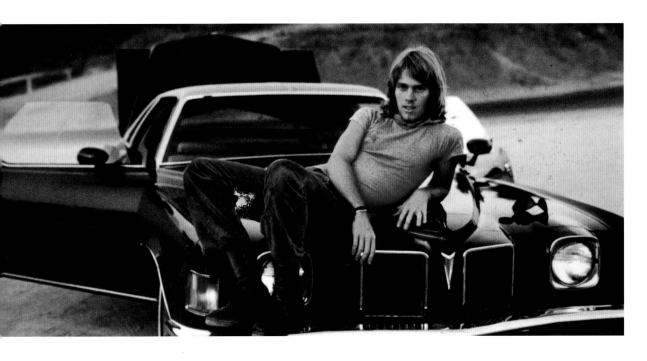

Christopher Makos

Foreword

Sorry, Wrong Number. Long before Facebook, Twitter, YouTube, there was just the phone. That's how I met Lance. I was dialing a phone number, and suddenly I hear a voice, asking me, "Who *is* this?" and of course my response was, "Who is *this*?" It turned out we were experiencing what, at the time was called, "crossed lines," something which really doesn't exist today. Lance's exuberance could be felt over the phone and ignited my curiosity about this person who was sending so much "visual energy" over the wires. We immediately hit it off, and decided we should meet. He told me how he had just moved to New York City, being here for a documentary on his family, a program called "An American Family." This fact made me even more curious.

After our telephone call, Lance and I finally met, and became friends; not only friends, but family. I actually went to Santa Barbara to meet Pat, Bill, Kevin, Grant, Delilah and Michele. I escorted Michele, even, to her high school prom—something I will never, ever forget. Can you imagine: At the time I was a full grown adult, living in New York City, taking a teen to a suburban high school prom? I felt like Diane Arbus, but rather than viewing, living the scene. Actually, I did take a few pictures, but was so overwhelmed by the experience that the pictures were only a starting point to what would become the beginning of my full-on on relationship with the entire family.

Throughout the years, Lance and I shared so many moments, like his appearance on the Dick Cavett television program, the screening of the "American Family," and of course the trauma that resulted with the family appearance as the cover shot of *Newsweek* magazine. Lance was not only creative, he was sensitive, smart, pointed and had an uncanny sense of the moment. He was a writer, a musician, a lover of animals, a lover. The last thing that Lance was not was "Gay" in the stereotypical sense. He was way too intuitive, way too self-aware to allow himself to be Gay. But unfortunately, after the *Newsweek* cover story, he was type-cast as the poster child for Gay, something I wouldn't wish on anybody, let alone Lance.

But like everything in Lance's life, he was always able to deal with what was given him, and turn it into something that would work for him. In this case he turned his talents to music and writing. Lance loved music, he loved his group, Mumps, he loved the Music Scene. I have to say, I loved Lance's writing. The sense of commitment to whatever he did, whether it was a new friend, a new song, a new taco stand, just the sense of the new was something that we shared. That's what meant something to Lance, to *be* where he was, in the moment: to feel life and not to look too far into the past, and not to stare too far into the future, but to love the moment. That was Lance. That's why when I was asked to work on this book, I decided it had to be of the moment: Not a history lesson, not a look back, but just a look. I hope you enjoy what you see. Christopher Makos

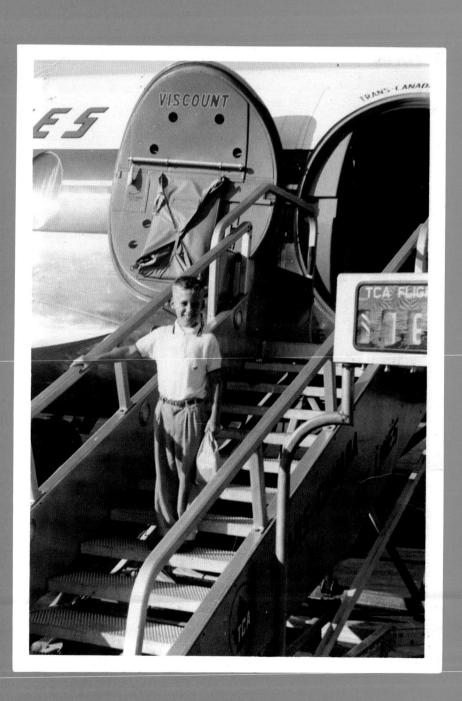

Introduction

The Master of Mischief. Lance was a gift. Difficult and unpredictable, he did everything I told him not to do. Yet, being with him was usually such great fun that I'd forget that he was the master of mischief. His interests were many and varied and the enthusiasm he brought to each was contagious. Explaining him is like trying to capture the will-o'-the-wisp.

Alanson Russell Loud was born on June 26, 1951 at Scripps Memorial Hospital in La Jolla, California. He immediately made his arrival known with high-pitched, ear-splitting wails that prompted one nurse to say I named him well because he had a voice that pierced like a lance. That voice was never really stilled until his death on December 22, 2001. Of course I hear it now and always, always will.

When Lance was four, he wanted a horse for Christmas. He was a dedicated fan of the TV show, "Davy Crockett". His favorite clothes were a Davy Crockett suit and a coonskin hat. All he needed was the horse. For us, this was an impossible request, so we got him a kitten instead. He promptly named the kitten Horse and was as happy with that cat as if it had been a seventeen-hand destrier. Then there was the time just before Easter that he told his weeping brothers and sisters that the Easter bunny was dead.

Lance loved his family and friends, all music except disco, with a special passion for rock and roll and Rufus Wainwright's music. He loved Andy Warhol, thrift shops, wind chimes and yard sales, Doris Lessing and talking on the telephone. He collected records and books. He loved Latin men. He loved cats and clothes and riding on his motorcycle. He loved to sing and eat and knew every taco stand in Los Angeles County. He loved movies and pop culture. He was a gifted swimmer and juiced piles of fresh vegetables every day.

When he became ill, someone asked him if he believed in anything. He replied that yes, he believed in baked goods. I think that what he was really saying is that he believed in life itself. Like many gifted people, he was pursued by his own demons and turned to drugs to keep them at bay.

It seems to me now that he had a premonition that his would be a short life because he crammed so much into it. He simply jumped into the world with fearless enthusiasm and disregard for his own life. He liked living on the edge. He had a quick wit and engaging charm that drew people to him. He was highly opinionated, not always right and possessed a huge vocabulary that served him well. If there wasn't a word for it, he'd make one up. He once told me that he hoped I wouldn't become "hagular" in my old age.

He could be and often was witheringly sarcastic. His riotously funny sense of humor saved him from being overbearing. He was so beautifully human and courageous. He is still a forceful presence in our lives. Lance Loud was a gift. All mothers see their children as exceptional, and I do too. However, in my case it happens to be true. Parents are not meant to outlive their children. I miss him every day and always will. Pat Loud

Overture

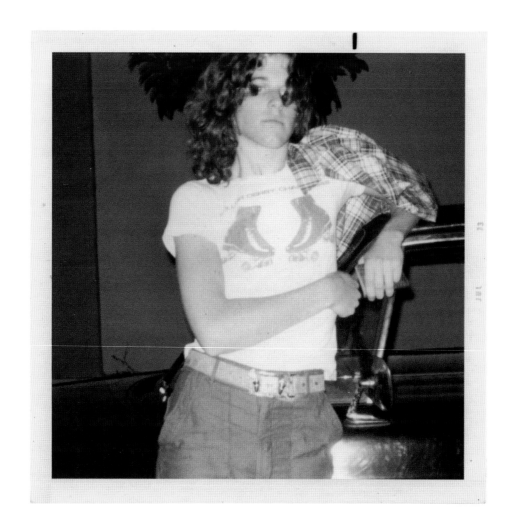

Kristian Hoffman

About Lance. I met Lance in Mr. Baker's art class at Santa Barbara High School. There were wide blond formica tables in the middle of the room, and students were seated around them, dutifully dabbling with papier mache. In the far corner was the square brown desk where Mr. Baker sat—by all appearances a closet queen of the old school—his small frame nattily dressed in tight pin stripes and a colorful shirt, with a slightly alcohol-ravaged look to his pixie face, sharp eyes and a sharper tongue.

Next to him, with their backs to the rest of the class, were students Lance Loud and Guy Zietz, and because the only available seat at the large table was near that desk, I overheard the trio's wickedly deprecating banter, sarcastically and cleverly deriding most of their classmates' earnest efforts, and, more often, just carrying on a snickering diatribe about anything and everything besides art.

I was immediately seduced, of course. Occasionally Lance would visit his "real" seat to add another dead avocado leaf to the neck of the immense ungainly papier mache dodo he was supposedly "working" on. But he would quickly return to the charmed corner where Mr. Baker's anointed favorites could continue their lively gossip while they diligently worked to finish Mr. Bakers' carved plaster flower arrangements, which Mr. Baker would later sell as his "art." It was a mark of Mr. Baker's humor that even though he was engaging in a cynical exploitation of the talents of his favorite students that bordered on the illegal, he would cheerfully give them D's for not finishing their own projects. It just smelled like the home I had never had.

I had no way to ingratiate myself into this fantastic coven other than my reasonable facility for drawing, and intended to best the rest of the class if that's what it took to get their attention. I came from an academic background in which our family had honed hurting each other with cruel acidic taunts to a razor skill, so if I could ever break the invisible wall and get past my shyness, I felt I had something to contribute.

Lance quickly fell for my ruse, and soon was paying me fifty cents apiece for inept magic marker drawings illustrating the lyrics from Donovan's "Mellow Yellow." I think my charm was immensely enhanced in his eyes when he quickly discovered that even though I was only 15 1/2, I already had a learner's permit—and a Volkswagen. Suddenly he was my best friend!

Thus was our lifelong pact, borne of commitment to music, verbal gymnastics, verboten destination, and the sadly prosaic fact that I could be of use, begun. Lance was also mightily endowed in a discipline in which I had woefully little expertise whatsoever: a will towards cultural, societal, sexual and spiritual exhilaration. I was the one who defaulted to observing from a safe distance, and finding fault; he was the one who was equally prone to immediate disenchantment, but said, "Let's just jump anyway! Who knows what we may find?"

I was soon converted, and we symbiotically schooled each other to be lifelong enthusiasts. As I look back, that very enthusiasm was often presumed by our peers to be the affect of clueless buffoons, but became, in our minds, one of the most spiritual pursuits of all. This would be the crux of our lifelong love affair, which was that of friendship, despite the more prurient imaginings of some under-informed observers.

So Lance and I shared our musical obsessions while taking our unsanctioned sense of destination in ever widening circles: I brought him into the world of The Small Faces, Sparks, and The Kinks (whose LP at that point was the least selling album in Warner Brothers History: "Village Green Preservation Society"—an LP which I diligently shoplifted multiple copies of from Isla Vista's "Morning Glory Music" beneath my shabby Portobello Road Sgt. Pepper redux jacket, under Lance's helpful but less litigation-adjacent tutoring, so we could distribute them amongst the many non-believers at SBHS—some of them even came around!). And Lance brought me into the world of the Velvet Underground and the Stooges. We both loved Love, and discovered the fantastic vagaries of Bowie's ever-evolving output together.

Meanwhile we would see how far the rudimentary bait'n'switch, "I'm going to the movies with a friend," could excuse us from our respective households while borrowing the family station wagon, or (with more disastrous results) Pat's yellow Jaguar XKE—at first, timidly, merely to the Whiskey-A-Go-Go, to see The Kinks, T. Rex, and the Velvet Underground, and attending late- night soirees with the G.T.O.s and Sable Starr at Ben Franks or the Odyssey, and later, somewhat more infamously and with a tad more panache, to Altamont.

When we heard the "hippies" (whom we openly disparaged, although Lance was dating an art history professor from U.C.S.B. who was openly a Grateful Dead—UGH!—fan!) were burning the bank in Isla Vista, unlike other Santa Barbarians who locked their doors against the coming revolution and tremulously witnessed the event through grainy 60s broadcast journalism, we rushed to get to the scene, taking shelter in a phone booth just outside the bank, and giggling maniacally at the untoward display of tear gas and college students run deliriously amok.

There were so many other wonderful things that came out of that fateful meeting: leaving school at lunchtime to go run up a tab on his parents' account at the old El Paseo or the Coral Casino; sneaking out to Isla Vista beach to catch Edie Sedgewick romping in the waves. Lance showed me how to get out of P.E. and into June Lane's significantly less stressful dance class, with a parental note. That was where we met and befriended Alonzo King, who was eventually to become the visionary choreographer of San Francisco's LINES ballet, but was then just another handsome 60s addled kid with a hefty dose of scathing wit and a psychological undercurrent that only later revealed itself to be our silent bond of sexual outsider-ness. That bond did not remain silent for long. (And Alonzo would accompany Lance and me on our first ill-fated relocation to NYC!).

I was also invited into Lance's home where Pat, with an infinite resource of motherly warmth and patience for ill-begotten strays, would welcome me without reservation. This was the home where I learned that, unlike in my own home where meals were most often chilly affairs to be merely endured, the Louds found food a constant resource for celebration, salty stories, and conviviality. Pat, whose every move in the kitchen resulted in something delicious beyond my deprived culinary imagination, told me with charitable indulgence, "Food is love!"

I was astounded that, when Lance and his siblings would gather together on the sofa to watch television or listen to records, they actually touched each other! My six siblings and I had totally mastered the balletic technique of deploying in any space, no matter how confined, without any form of corporeal contact. If this balance were ever shattered, an orgy of revolted gooseflesh cringing would inevitably result. And here were a group of boisterous, hilarious children who actually enjoyed physical proximity, even intimacy! I had never looked at the world through that lens before. I wanted in!

As soon as I met Lance, my regularly decent grades took a decided plummet, as he encouraged me to join the school of life and abandon almost any discipline to which I had any tenuous claim. We'd be sneaking out of school past the quad, en route to some fantastic divertissement, when a typical scenario would include Timothy Bottoms, with whom Lance had apparently already engendered a certain enmity, yelling out, "Hey faggot, why don't you give me a blow job behind the bleachers?" This was transparently meant as an insult, probably commenting on Lance's penchant for criminally clinging striped muscle shirts, but in my nascent stirrings of unformed queer-dom, it seemed thrillingly salacious, and that very ostracism made being with Lance even more exciting. Mahatma Lance was already steering me toward what would become, over the course of the next few decades, all of my most cherished misadventures.

Lance was far more sexually advanced than I, and many were the times when I was told to "Wait in the car for a minute, okay?" while I wondered outside a variety of public restrooms, from Cabrillo Boulevard to Del Playa Drive, "Really, how can peeing take so long?"

But he later ushered me, as would a charitable patron directing a clueless apprentice, into the acceptance of my own "bent," if you will, of desire. He even generously had his college art professor boyfriend gently accept what wilting flower of virginity I had to offer at that awkward age.

Oh! The contemporary horror from this vantage towards that innocent time! Please remember, this was during the fleeting reign of "If it feels good, do it," "Free Love," and the more politically charged, "Girls say 'Yes' to boys who say 'No'!"

Society had not yet claimed that the human psyche has so little resilience that a brief ejaculation between two people of somewhat disparate age groups required eternal branding, house arrest ankle bracelets, and damnation through prison or the absolute ruin of the elder's life.

I am very grateful to have had a guide towards self-acceptance as expert as Lance, in a time when sexuality was celebrated as, in pop culture at least (by example of your Mick Jaggers, your David Bowies, your Lou Reeds, the dandified haberdashery of The Small Faces and The Kinks, and the entire cast of "Hair"), an elastic adventure with many delightful destinations from which to choose.

Somehow, when "An American Family" started shooting, it just felt so oddly right. We felt so close in spirit to the pop icons we most admired, as though being filmed as we naively groomed ourselves for automatic entrance into that pantheon seemed not only completely natural, but inevitable.

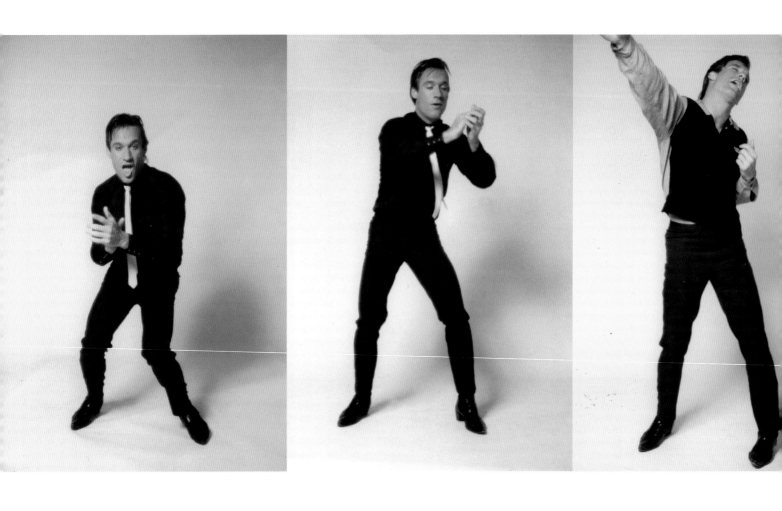

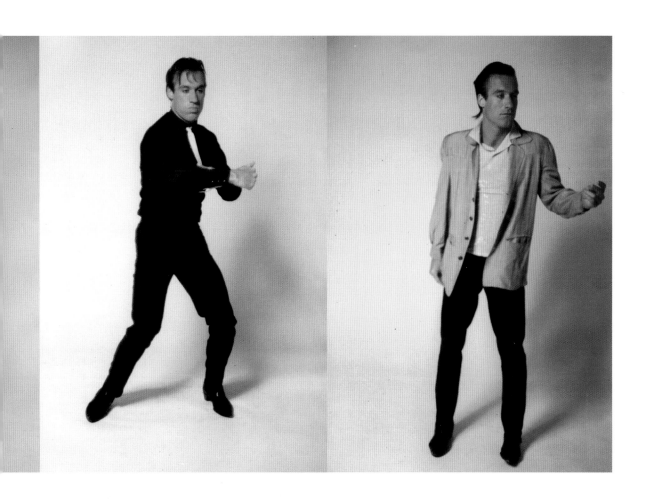

We quickly grew nonchalant about having camera crews follow us from Copenhagen (where we arrived under the vague tutelage of Lance's then boyfriend, Barry Bryant, from the notorious Silver Apples, who planned some conceptual act of "art" by painting the words "Milieu Protektion" on a Swedish bridge—an act which didn't seem to happen, and we didn't care) and being filmed playing Incredible String Band songs in a five-hundred-year-old farmhouse, to Paris, where Andy Warhol semi-star Rene Ricard assumed by the attendant cameras that we could afford to pay his outstanding bill at Le Drugstore. As we watched the Paris moon on the night of the Apollo landing, accompanied by an Yves Saint-Laurent model who didn't speak any English at all, destiny seemed to be firmly in our pockets—all we needed was a couple of songs a little more costume-specific thrift shopping.

Another skill Lance taught me was: When in doubt, just go. When I was seventeen, Lance and I moved to New York with no plans whatsoever, just to be near The Factory and away from the hippie tropes of California. We did what all aspirant young runaways do—default on the rent and fail in every endeavor, but all the while gorging on every sensation that decadent, nearly bankrupt culture-pit during the panic of white flight had to offer. That was a magic time of the New York Dolls and our crazy friends from Parsons School of Design, who let us stay in their dorm rooms at One Fifth Avenue. Alonzo was our den mother who could actually cook, and Lance endeared himself to his long- time friend Norman Fischer and I to Danny Fields. Between them, they got both of us into all sorts of fabulously appointed rooms full of celebrities who ignored us with chilly deliberation, and we posed idiotically in booths at Max's Kansas City, having everything except for the skill or discipline to actually amount to anything.

There was sort of a predictable mini-collapse when we had to go back to Santa Barbara in mild ignominy to live with my mother—which is when we decided we would never arrive anywhere "without portfolio" again—and began making our musical plans in earnest. It seemed so frustrating that I even tried attending the dreaded Art School again, but Lance's web of irresistible charisma and my disappointment with the cold ascent of Conceptual Art conspired to make us work in my mother's garage on the act that would one day become the Mumps. Months of this suburban self-indulgence passed, and somehow, after the fiasco/triumph of the original "Am Fam" broadcast, the Dick Cavett Show beckoned and Pat insisted that unless her children were given a musical showcase, the Louds would not participate.

Of course the one caveat was that Pat also insisted we fire our back-up singers and bass player so Kevin, Delilah and Michele could be in the band! Family affair indeed. But we got to keep SBHS alumni and resident geniuses David Collert and Jay Dee Daugherty. So with very little moral compass, and even less apparent talent, we completely embarrassed ourselves on national television with a bawling, braying version of what would later be honed into one of Lance's classic compositions, "Muscleboys."

I happened to be watching the delayed broadcast at the Greenwich Connecticut home of Steve Paul, with artist Duncan Hannah, and they both looked at me pityingly and said, "That was awful."

Of course I started to cry, because they were absolutely right. We made Grant's sweet-voiced but somewhat pedestrian solo acoustic reading of "Blackbird" seem like musical gold.

But here was where the Lance life lesson kicked in: he insisted that we stay in New York and just brazen it out. Dick Cavett had been our ticket back to the city in which we felt more at home than any other, and even in the face of this most recent humiliation, Lance believed in our genius for life—or at least his genius for it—and that it could carry us both to our shared destination. Lance never entertained a single doubt; not when everyone but Jay Dee Daugherty quit the band and left us, not when finally Jay left us as well, and we rattled uncertainly through a rash of musicians that were completely unsuited to music itself, to say nothing of our fledgling Kinks/Bowie amalgam.

Lance even believed when we were relegated to practicing in our apartment as I wrote songs on the only instrument we had—a miniature toy thrift shop Emenee Organ. And somehow that steadfast belief in, and even thrill to, the adventure of creating our scene morphed into Mumps, which I may say without irony was Lance's and my most satisfying collaboration in defining what we wanted and expected from art, and life, and our spiritual pursuit as enthusiasts.

Certainly it was gratifying when through arduous determination we and our cohorts Rob DuPrey, Paul Rutner, Kevin Kiely and Joe Katz managed to make Mumps a headline act at CBGBs and Max's Kansas City in New York City, and in punk clubs across America. Certainly it was gratifying to receive a certain amount of critical and popular adulation that made our trek into the realm of polished pop nuggets of sardonic observation seem, at least momentarily, to be a "success." Certainly it was disappointing when, in what many have assumed was an only slightly veiled policy of homophobia on the part of contemporary record labels, Mumps remained the only unsigned act out of the original crop of CBGBs era headliners.

But more than any of that, it was Lance's unwavering, contagious belief that we were making some kind of *magic*, that we could simply *will* our lives to be the most exciting adventure of all, and if we just believed that, nothing else mattered. History has thankfully been kind to Mumps, even though, in our own time, frustration at our inability to rise out of the Bowery with the ease that seemed to be afforded our peers drove us apart. Mumps are blessed that two highly regarded compilations have since been released, and the music lives on.

But that's almost beside the point: It was Lance's determination to live art, live music, be in music, and just be music, along with his other ravenous hungers to have and to be all the other sensations of taste, sight, sound, and sense that were possible. He wanted to be that in how ever long we might stay on this earth, and perhaps his flame burned too hot because of that will, that desire. But it was that sense, that all-devouring flame that made you feel that when you were with Lance, there was no other place. Lance was the destination.

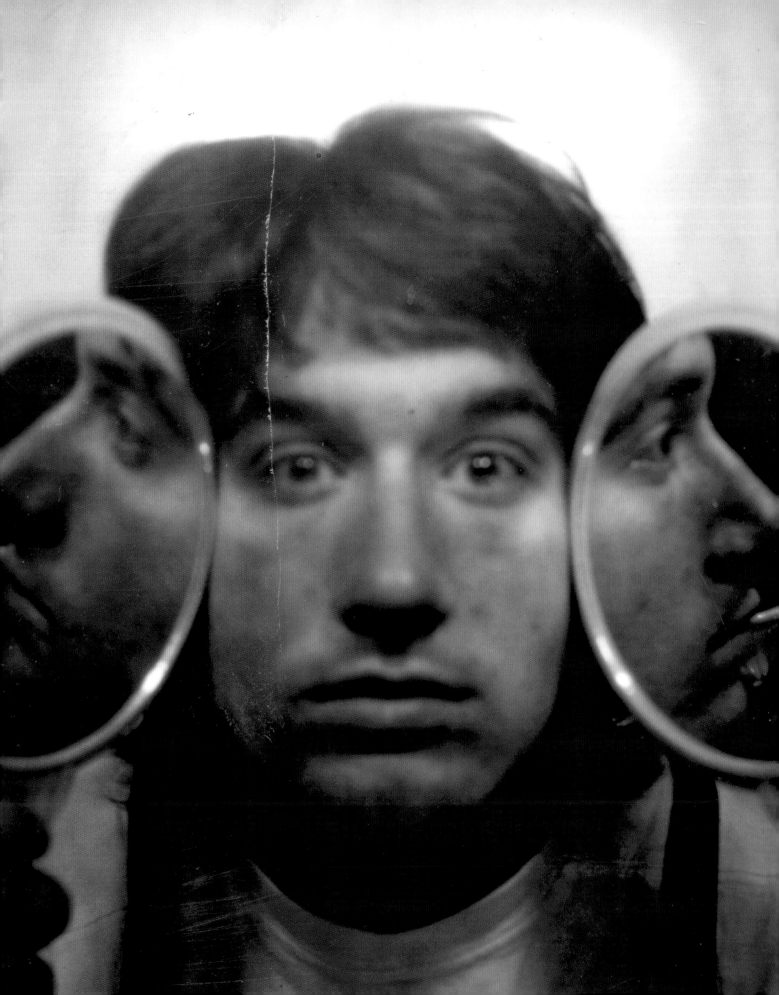

Lance was always passionate about words—even in high school he juggled words into unlikely combinations that shouldn't have worked, but revealed new layers of meaning through the impetuous humor in his whimsical juxtapositions.

Being privy to Lance's confabs was to be enticed toward those fresh understandings. Occasionally, his fluid outpouring of constantly surprising observations would slow a little, and you'd see his brow furrow in a search for a word. He was, in effect, writing as he spoke. The result of that search was always perfectly surprising, and surprisingly perfect.

So it seemed Lance was made for writing. But was writing made for Lance?

Lance seriously pursued a career in journalism after the Mumps broke up, but despite writing many brilliant articles, somehow Lance regularly frustrated those editors who, so seduced by his verbal legerdemain, were determined to help him reach his writing zenith. No matter how many chances given, or how much unconditional support, Lance could rarely finish. It was almost a form of agony. It seemed so unlike this person whose entire lifestyle was ejaculatory; one that was all about climax.

But ultimately the reason seemed as simple, and as profound, as Zen (aside from the drugs!): Lance's craft was not about saving. Lance could astonish with Heath Robinson gimcrack verbal constructs so jerry-rigged with untoward contradictions that they should be forever earthbound, but, due to his gift, soared to dazzling heights like a cathedral made of morning light. But Lance's real forum for writing—his speech—was in the ephemeral of the now. Lance lived and spoke his writing in real time, like a taste meant to be savored in one course, and then balanced with altogether new flavors in the next. That writing was more dance than poetry, more theater than novel. In the same way that Lance was the destination, Lance's greatest writing was the now.

Another aspect of Lance's character that was less discernible in the mad and often superficially selfish rush of youth, but later proved to underpin all of the grand gestures of his life, was a sense of family. Once you were in Lance's family, you were never out. As Lance often said, "When the Louds love you, you stay loved."

I was lucky enough to be introduced to Christopher Makos through Lance very early in our first New York City meanderings, and Christopher kindly allowed me to room with him for a time at his apartment, helped me with my design for the insert for the New York Dolls cover, was there to photograph Mumps (and snidely deride us!) when Mumps finally made it into Interview magazine. Christopher remained a close and dear life-long friend to Lance, despite many emotional conflagrations between them, some of which I have very colorful records of in my diary!

It is a measure of the power of Lance's sense of family that Christopher is once again, and still, in my life and the life of all the Louds. The extension of family was a gift of Lance's that he gave unstintingly, no matter how fantastically dramatic the ensuing contretemps!

It was also a measure of how close Lance had held me as a family member that, as I found my first "true" (while it lasted!) boyfriend while the Mumps were dissolving, and when after the laborious last months of the Mumps wound down and I professed my desire to pursue the other many musical flavors and projects of that magical East Village time, Lance regarded that as an horrific betrayal, and we went through a "divorce" of sorts. I don't think it ever occurred to him that we would not be Ron and Russell Mael, or Gilbert and Sullivan, or some sort of binding creative partnership for the rest of our lives.

I don't know if there was anything more painful in my life than discovering how deeply he felt that betrayal, and how closed he would become towards me for a time. The impenetrable vacuum of his regard during that breach left my heart empty and still.

But it was also the measure of truth in that lovely phrase, "Once the Louds love you, you stay loved," that this separation simply couldn't last forever. It wasn't in Lance's life vocabulary to allow that. I was blessed that we became fast friends again after a couple of years, and he lead me on still further adventures, wayward and otherwise! He absolutely forced me upon Rufus Wainwright, who has inexplicably and delightfully consented to collaborate with me on all sorts of crazy stuff ever since, and at so many turning points of my life Lance has still been the catalyst, the orchestrator, the unstable element that makes everything positively glitter with wild frisson.

And I'm so grateful to have so cheerily been welcomed back as a surrogate Loud into the family, easily one of the greatest gifts in my life. I was blessed to have spent many of Lance's final days with him, where his unerring gift for outrageous wit that made everyone giggle even in their discomfort, his nimble wordplay, his will toward absolute love (and expensive pastry) and his desire to get the latest of absolutely everything in music, lasted until the last minute.

Even after the last little nap Lance nodded into and on his journey into some celestial pantheon where he certainly must be laughing at us now, he has helped me know that even after all this craziness, it isn't only the love that survives. It is that crazed, hungry but ineffably loving adventurous spirit that makes all life more wonderful, and certainly makes the laughter come more easily, if you dare to listen for it. Kristian Hoffman

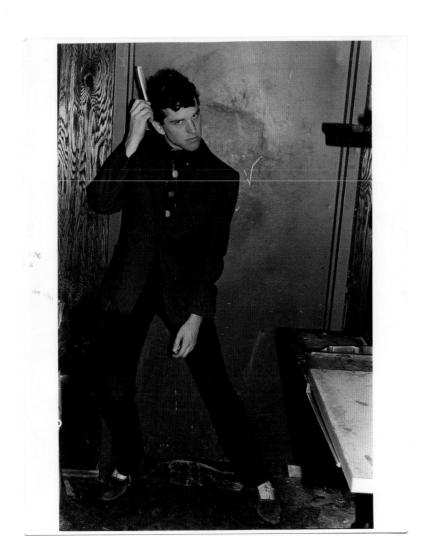

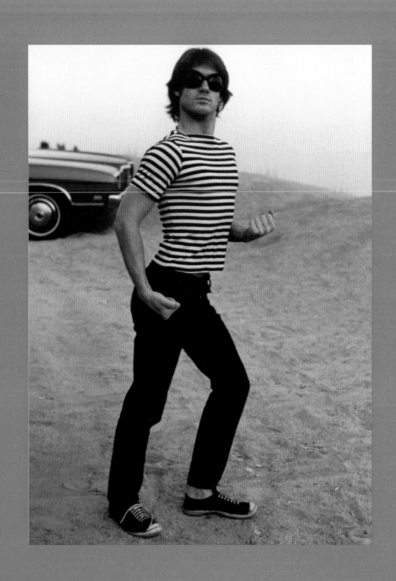

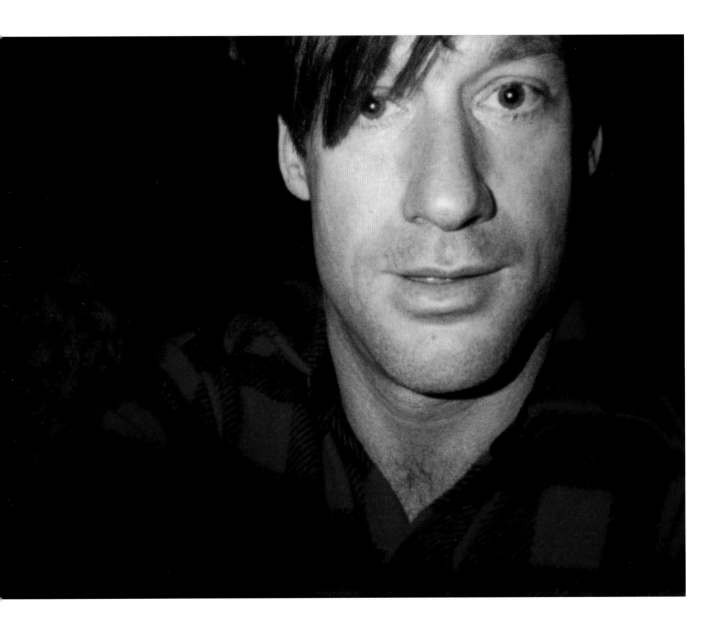

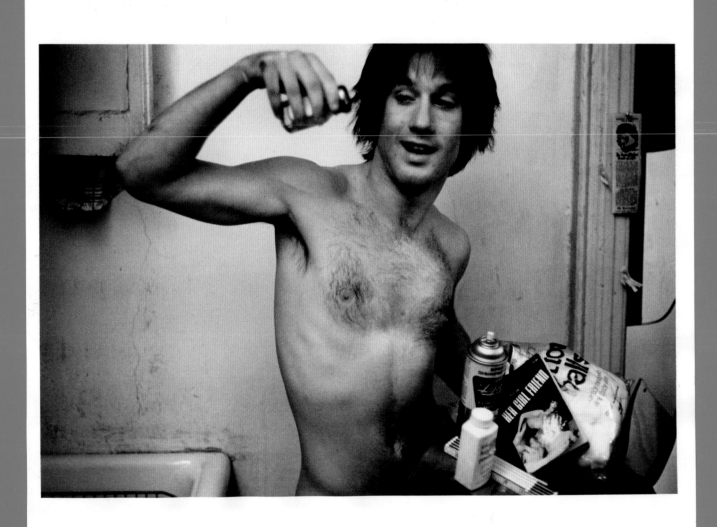

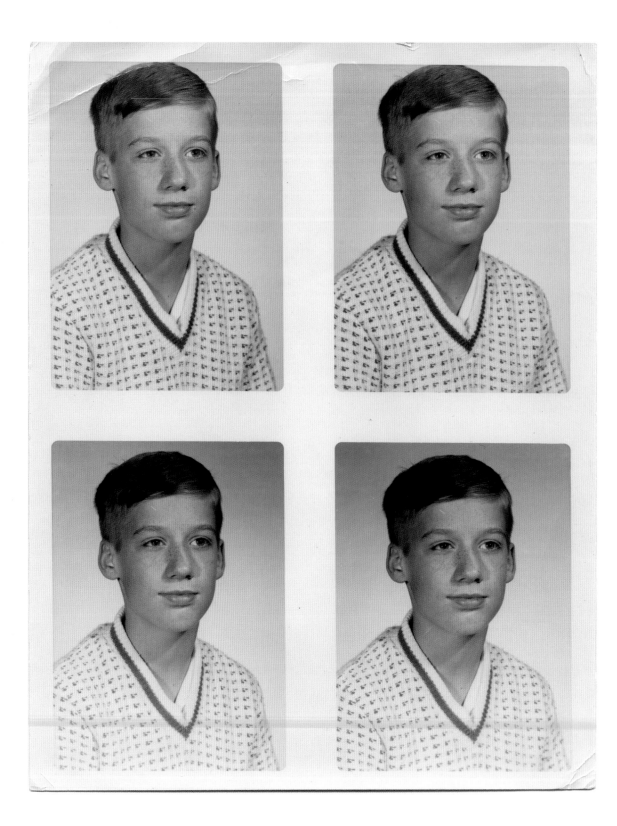

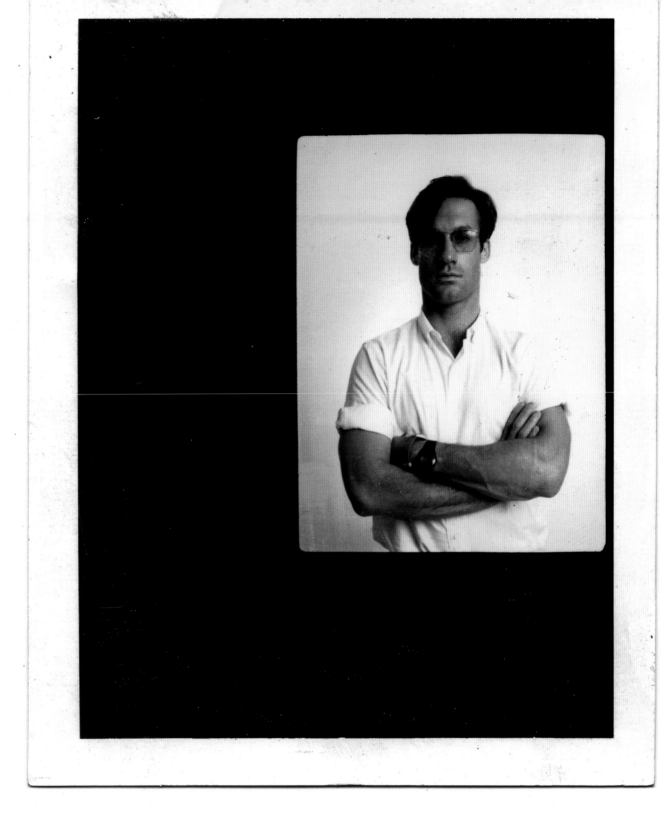

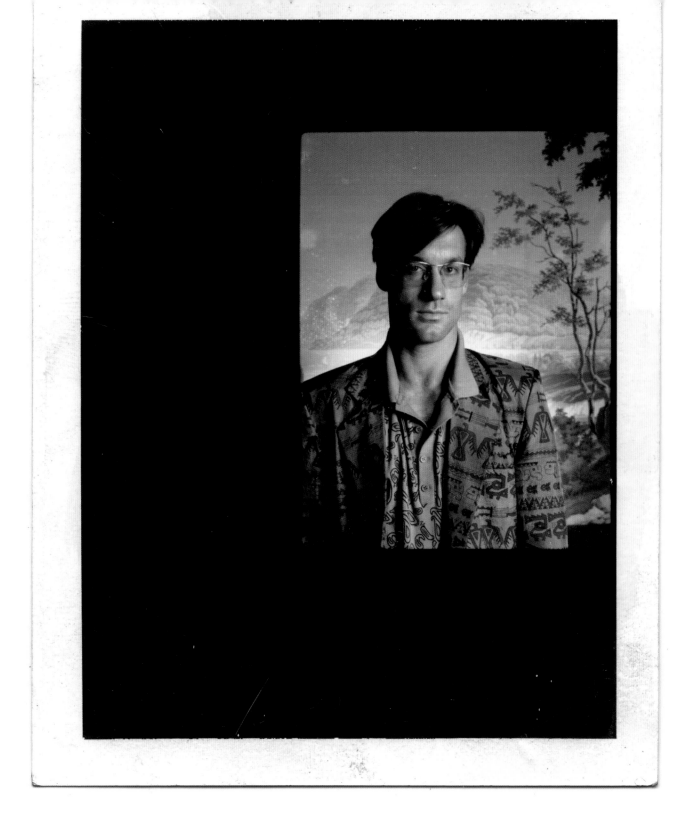

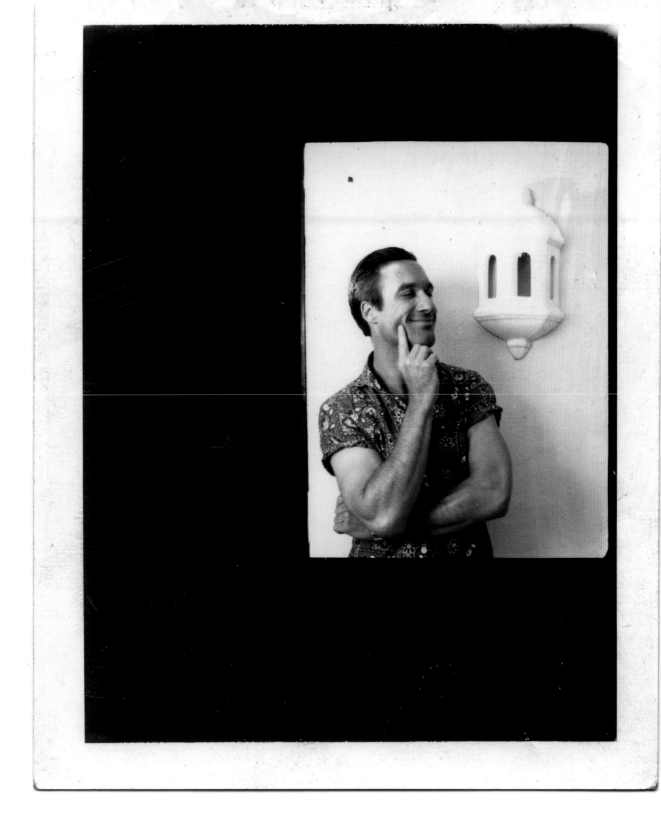

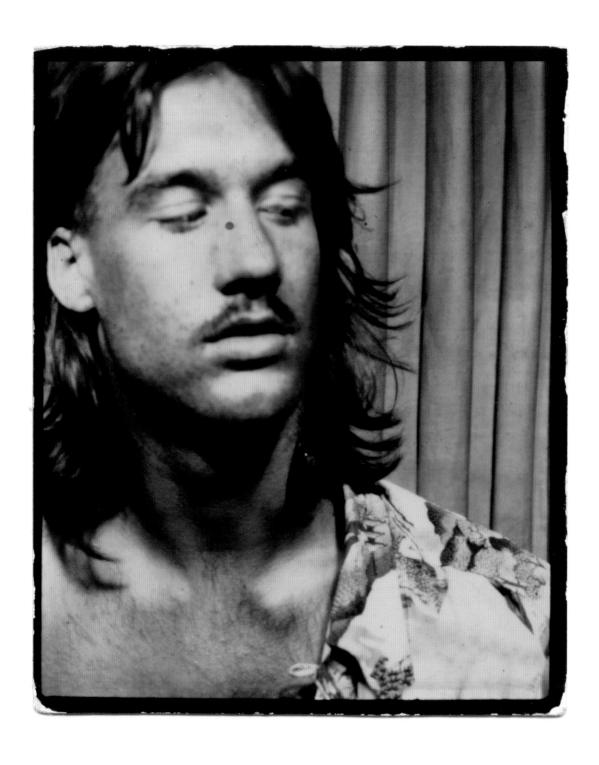

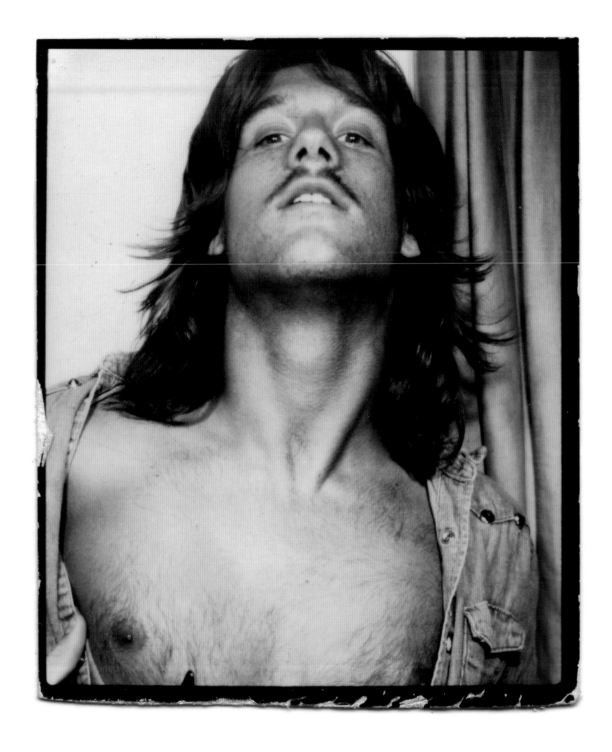

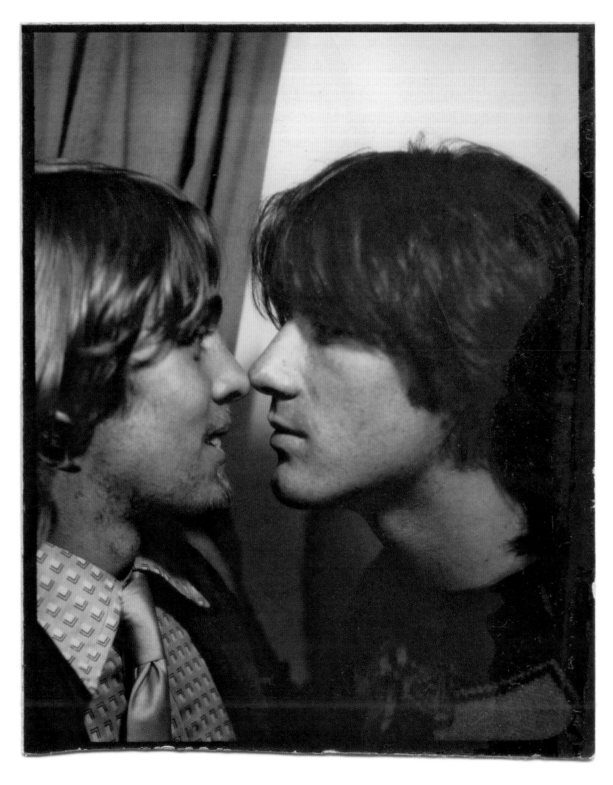

Chris Makos with Lance

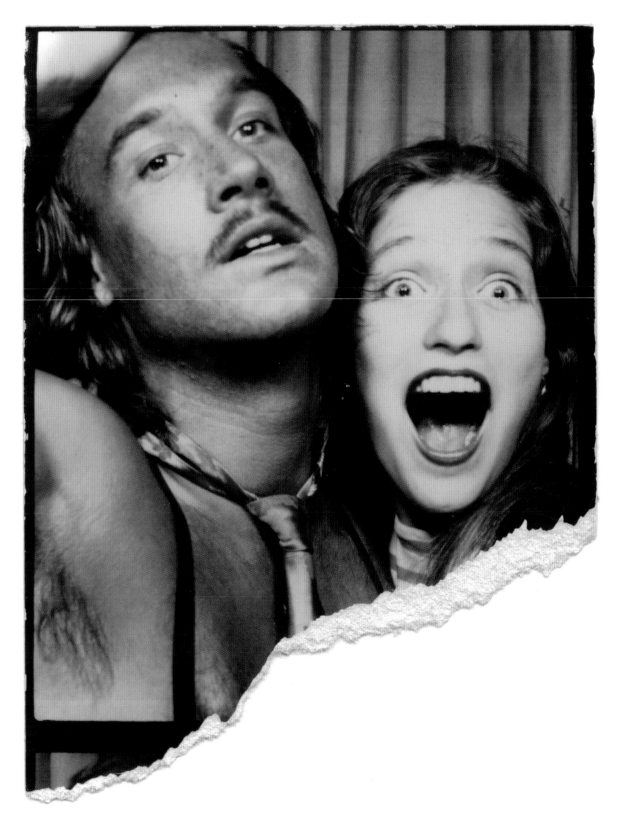

Lance with Dolores Ayres

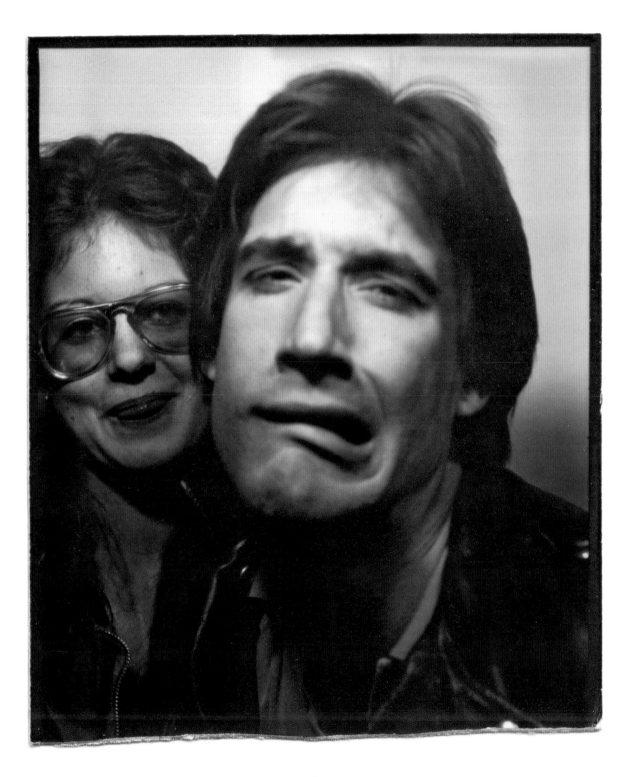

Katie Sondern with Lance

A Loving Friend. I first met Lance in 1983 when I was sent by *Interview* magazine's then-editor-in-chief, Robert Hayes, to assign him a story for *Interview's* 1984 Olympics special issue. Before our rendezvous, I'd spoken to Lance on the phone. He'd picked a designated food stall at the Farmer's Market as our meeting place and then, so we could find each other, described himself: "Look for the man," he told me, "with the brown hair cut into a lovely Dorothy Hamill wedge."

We met, I assigned him the story then we hopped into his battered convertible and drove around Los Angeles for the next five and a half hours, covering every corner of the city from a photo booth on the Santa Monica pier to a two-story mercado in East Los Angeles that boasted a quartet of mariachis. The band had such a bad sound system that the music would go into the amplifiers and emerge sounding like a squalling baby.

How could I not fall in love with Lance?

For the next eighteen years, Lance proved to be a friend who was as loving and charming as he was patience-testing: He was usually late, spun wildly unreliable tales (often, I later learned, involving me), and had a habit of borrowing things—a movie, a book, a pair of warm gloves—that would then vanish into the ether. But in one regard he was steadfast: Valentine's Day.

When February 14th rolled around, Lance never forgot me, and no matter the gift it was embellished with typical Lance-ian flair: When I opened the furry red, heart-shaped Whitman's sampler he gave me one year, the inside lid was covered with doodles attesting his love for me. Another time he presented me with a handful of red roses clearly fresh-ripped from a neighbor's yard.

But the year of the Poodle Power postcard was archetypical: Who else but Lance would have in his possession a card that doubled as a light switch cover and featured a fluffy, dewy-eyed doglette with his head at a perfect mournful tilt? Margy Rochlin

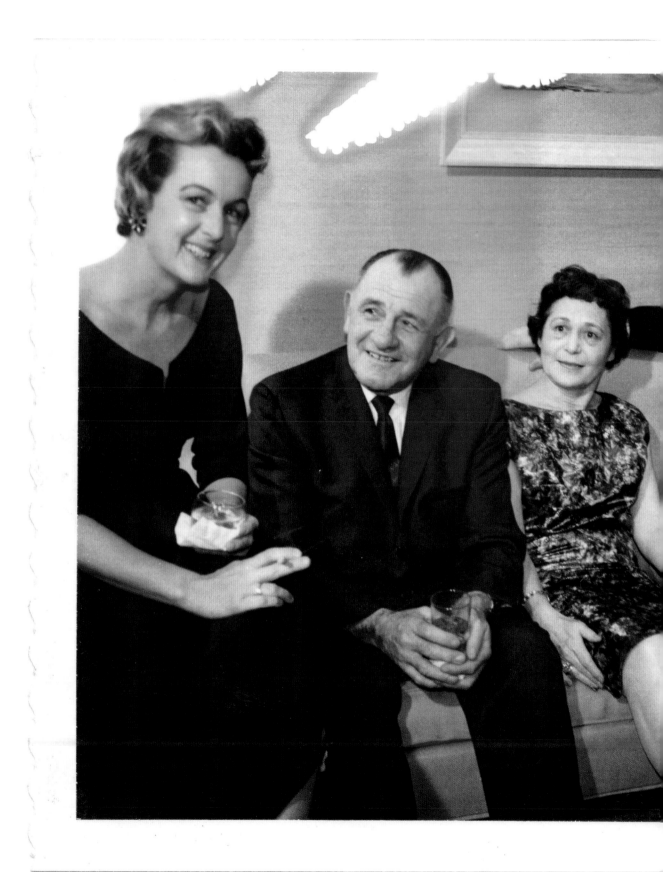

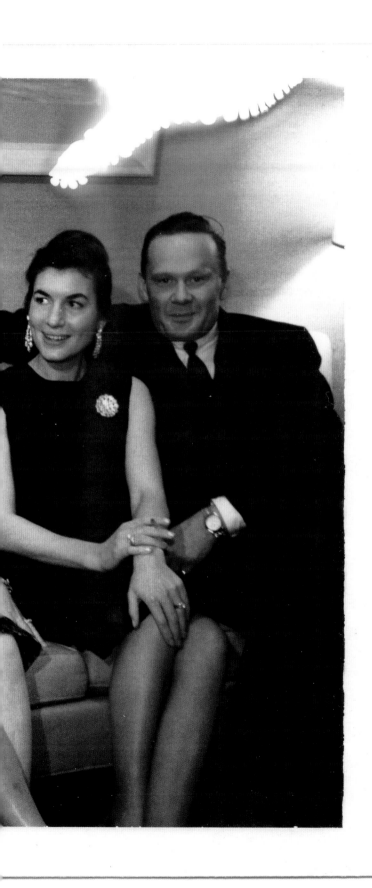

Joan Courson, Dr. and Mrs. Chapman,
Pat and Bill Loud, the night before
leaving Eugene, OR to live in Santa
Barbara, CA

It's a Beautiful Day. One summer day in the '70s, Lance Loud and I walked from Fire Island Pines to Cherry Grove to take in a lavish poolside party at the Ice Palace.

We were both in bikinis or Speedos for this perfect sunny beach day. Lance was carefree and taking everything in but I was walking along as usual with grim determination, my eyes on the ground, so intent on getting to the Grove that I was missing the glorious here and now.

"Ellis, look up!" Lance said. "It's a beautiful day." Shocked into the present moment—a radiance of sand, sea, and sky—I was so astonished by joy that I leapt into the surf and splashed around like the jolly kid Lance had transformed me into. After frolicking and bounding, leaping and lunging and laughing in the wild Atlantic, we were both wiped out by a wave that picked me up and tossed me head over heels in the churning water and then dragged me face down across the sandy bottom. Lance and I picked ourselves up and went hopping through the undertow back to shore. In all of the ruckus, fifty dollars in five-, ten- and a few one-dollar bills that I'd stashed in my bikini were now bobbing around in the churning waves.

As I stood helplessly contemplating my Cherry Grove fun money floating out to sea, Lance dashed back into the water and retrieved every single bill. Later, on shore, he handed me a wad of soaked greenbacks and said, "Here, Ellis. Now don't lose it again!"

He always kept an eye out for me because he knew Pat loved me. "Mom asked about you," he'd say. And he knew I adored and revered Pat. In a world that could be cruel and catty, I never heard Lance say an unkind word about anyone, and I always found his blithe spirit contagious. A lot of Lance Loud's happiness rubbed off on me over the years, whether I was watching him sing his heart out with Mumps at CBGB, the Phoenix Theater, or Max's Kansas City; enjoy delicious dinners at his Mom's condo on the Upper East Side with Richard Hell and the Voidoids; crash a Queens high-school dance with Christopher Makos; enter a sedate soiree at Bob Livingston's with a sleekly buff Adonis named Richard on a leash held by his ubiquitous companion Linda; or live it up with Martha Mitchell at "A Chorus Line" when it was still downtown and later in Martha's cavernously empty Park Avenue apartment and later still at the Pines beach house Bob Harris lent me for a couple of weeks.

My relationship with Ms. Mitchell had begun inauspiciously at the Sulgrave Club in the capital when she was the wife of Nixon's Attorney General. When she learned I was visiting from New York City, she said, "I'm going to see your Mr. Mayor, Mr. John Lindsay, crucified!" Later, under more salubrious circumstances, Pat Loud got us together at a party in the Manhattan home of her suave friend Mario Amaya, who'd recently survived the gunshot wound he received from Valerie Solanis at The Factory, as had his friend and principal target Andy Warhol.

As editor-in-chief of the Delacorte Press, I proposed a $250,000 contract for Martha Mitchell's story as the woman who brought down the Nixon Administration. We lunched at Le Madrigal with her collaborator, Washington newspaperwoman Winzola McLendon, and Martha seemed eager to get to work on the book. We began to see each other socially and she told me she was under surveillance and

her mail was being intercepted. One night she asked me to come into her apartment and look under the beds. She feared retaliation if she told the real story of the Nixon Administration, warts and all, such as revealing that Mr. President never drew a sober breath the whole time he was in the White House, and was drunk as a skunk that night he sneaked out to talk with the hippies at the Lincoln Memorial.

Winzola McLendon's Random House biography, *Martha*, would later state, "Ellis was no longer interested in the book; he had the feeling she would never do it. But he liked Martha. When she wasn't drinking, he says, she was adorable. He became her escort to many Manhattan parties.

Martha telephoned Ellis Amburn to ask if she could join him and his guests for a weekend on Fire Island. She was sad. She was lonesome. She didn't want to spend the weekend alone. Ellis said he'd be glad to have her."

Big mistake. I was in no condition to entertain anyone, let alone a world-class political figure, having been on a steady diet of MDA for a solid week, as a dealer admirer had told me I could help myself to his stupendous stash.

Martha came out in a limo with Pat Loud as far as Sayville, Long Island, where they boarded a ferry to the Pines. Martha proceeded to behave like diva, refusing to walk in her spike heels on the boardwalk, making Mr. LaFountain, the island workman, deliver her to my house on a tractor. Completely soused and disheveled, she needed a hairdresser before a party, so I went to the beach and yelled, "Is there a hairdresser here?"

Half the people on the beach stood up, this being Fire Island, and when I explained I had a scraggly-haired Martha Mitchell in my house, two beautiful young lesbians stepped up and said they'd be glad to help as they'd always wanted a front-row seat to history. Later, in my house, I looked in on them, and they were both in the shower with Martha, all of them laughing and having a jolly time. When they got through with her, Martha looked like Lana Turner. But she still refused to walk in her high heels, and I had to pull her in a little red wagon to a party at the opposite end of the Pines. As we thundered over the boardwalk at cocktail hour, Martha ensconced in the wagon like a pickled Buddha and I furiously jerking her along, chic lipstick lesbians leaned from the sundeck of the harbor disco as we passed and yelled, "Oh, check it out—maybe I'll get a man to pull me around the island. Always wondered what they were good for."

When we arrived at the party, the host greeted us in his birthday suit, and Martha angrily lectured him for being "un-American." When the girl who'd fixed her hair invited me to go skinny-dipping with her in the elegant, fountain-ed pool, I happily complied, and Martha glowered at us as we splashed about before dinner.

Finally she sat down with a woman dressed to the teeth, *tres soignee* in a black Halston sheath, and they chatted amiably for the rest of the party, Martha never suspecting that her interlocutor was the infamous drag queen Holly Woodlawn.

Pat and I climbed a soaring tower on the estate and watched the party from a safe distance, both of us smitten by a guy who joined us—a dead ringer for a young Clark Gable. Our feelings for him were completely reciprocated, and we'd still be with him 40 years later but he had a flight out of Kennedy the next day so we walked him to the pier and bade a tearful goodbye at dawn.

Then I had to go back to what was left of the party, load Martha in the wagon, and drag her back over the boardwalk to my house. After that Saturday night debacle, and although as Martha's host I was still responsible for her, I wasn't about to let her humiliate me again.

As Winzola puts it in *Martha*, "Ellis finally told her he thought she'd be more comfortable in her own apartment and suggested she go home. Martha refused to leave. The situation became so explosive that Ellis left his own cottage to spend the night with friends, leaving his guests, among them Pat Loud, the mother in the public-television documentary series, 'An American Family,' and her son Lance."

Winzola skipped over a couple of details: After fleeing my own house, I went to Cherry Grove and partied until noon, when I returned to the Pines to discover Martha, Lance, and Pat happily preparing to depart for a chi-chi dinner at the home of designer Angelo Donghia. I refused to budge, chastising Martha for getting all "likkered" up and spoiling my weekend.

She looked at me pitifully and said, "Didn't you ever mess up? Are you always perfect?"

I left in a huff and they all went off to the party without me. I found refuge on Bay Walk, in the home of an old friend, Nicky Rompapas. Back on the mainland the next day Martha promptly went on Mike Douglas's network TV show and said if she had her life to live over, "I would be quiet as a mouse."

She died the following year. It was all so sad. In retrospect, the one who comes out looking best is Lance, brave, kind and compassionate Lance, who stepped into the breech when I copped out. It was Lance who poured Martha Mitchell into the Flying Hornet, the ferry that finally got her back to Sayville. Handsome, bright, oozing-with-talent-and-good-will Lance, how I loved you, and love you still.

I'll let Winzola finish this sordid tale: "The next day, Lance Loud escorted Martha to the ferry, which the two were dashing to catch, when she slipped and fell to her right knee. According to witnesses Martha slipped, but Lance caught her before she fell completely to the ground."

He caught so many of us when we fell, like the catcher in the rye, who kept little children from plunging to their deaths. Rest in peace, noble friend. Ellis Amburn

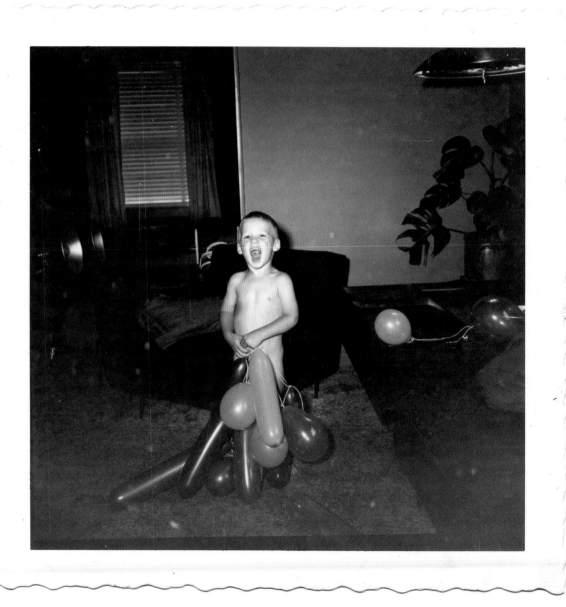

Lance enjoying an air bath

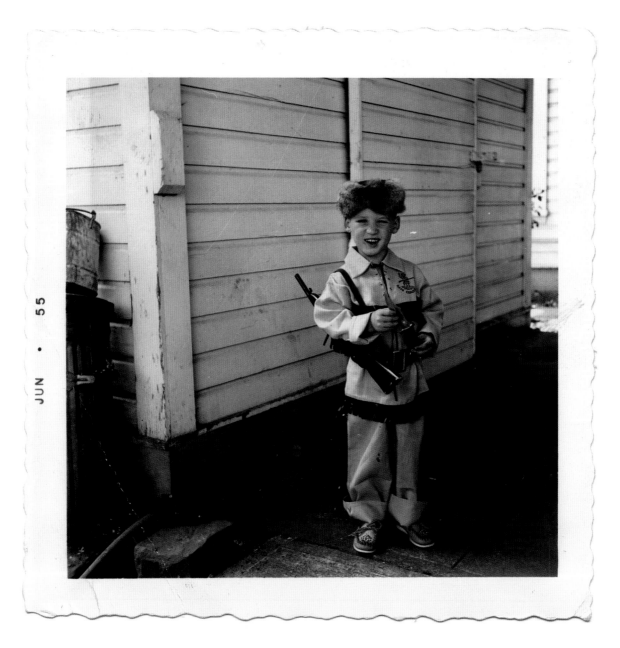

JUN • 55

Lance as Davy Crockett, age 5

Portraits by
Rocky Schenk

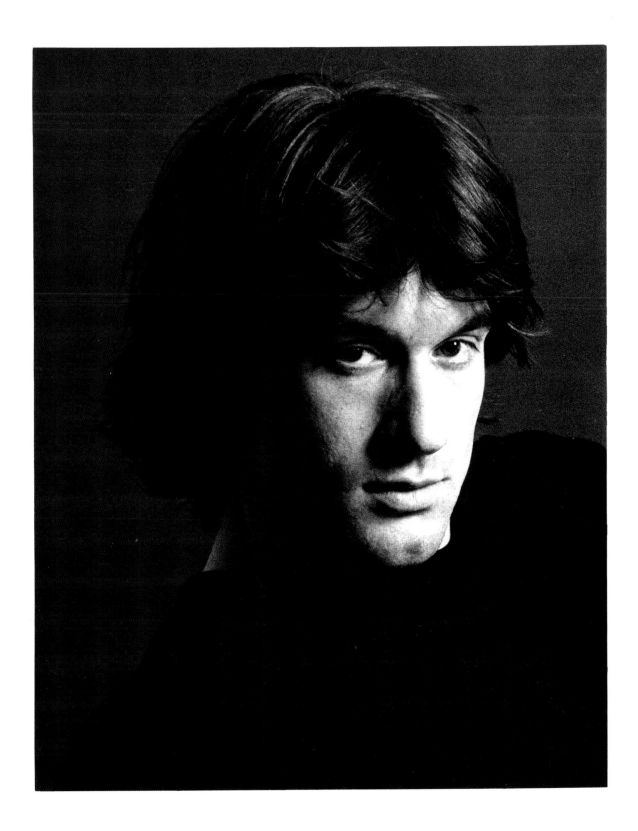

Fame

Epitaphf
AFTERMATH

Frought WERE the Kings
AS the CAUSE FELL through
BUT the people DIDNt CARE
For the morning mists still
CAME to the VALLEY and the
BIRDS still DANCED through
the AIR

Down IN the gullys.
DEAD HEROES DID ROt AND
the CROWS GAVE ANCESTORAL
CALLS
BUT ~~BIRD~~ NO SONG OF LIFE COULD
WAKE ~~from~~ OUR WARRIORS
AS theY DREAMt BEHIND
DEATHS GOLDEN WALL

Remember.........

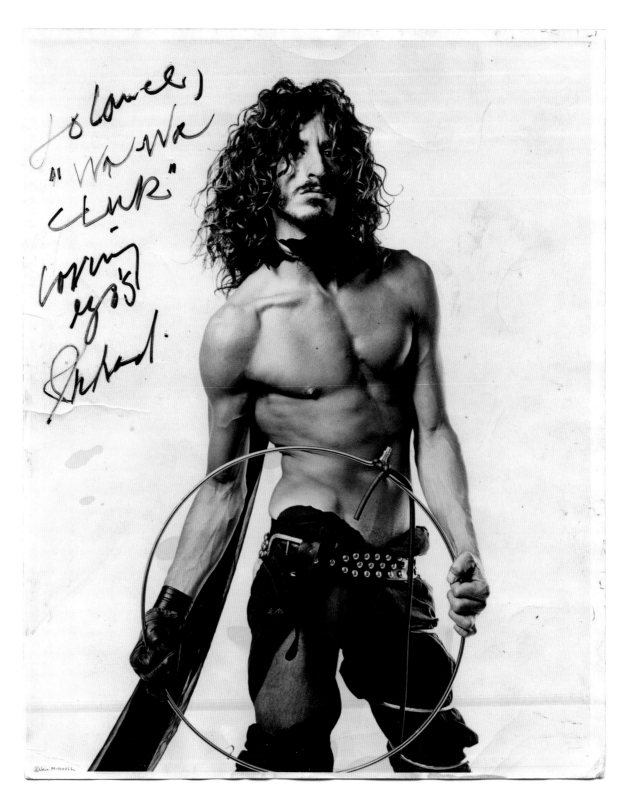

Performance Artist Richard Gallo

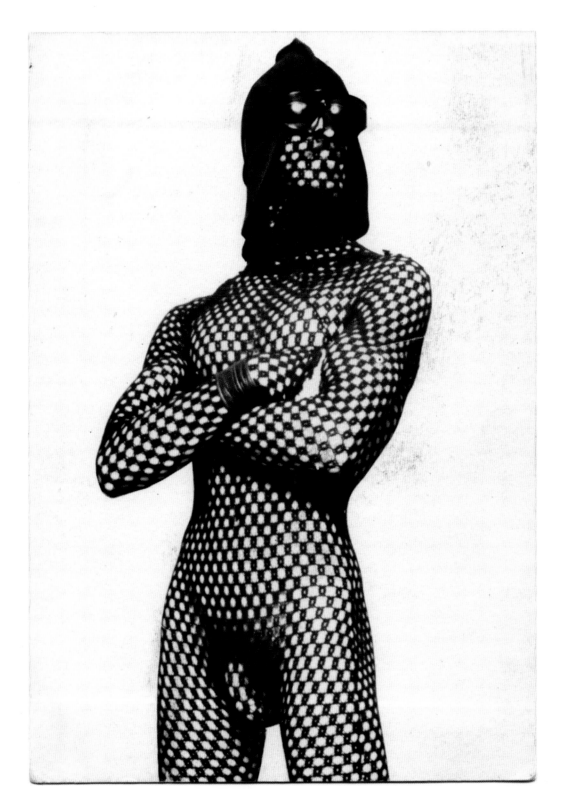

Performance Artist Richard Gallo

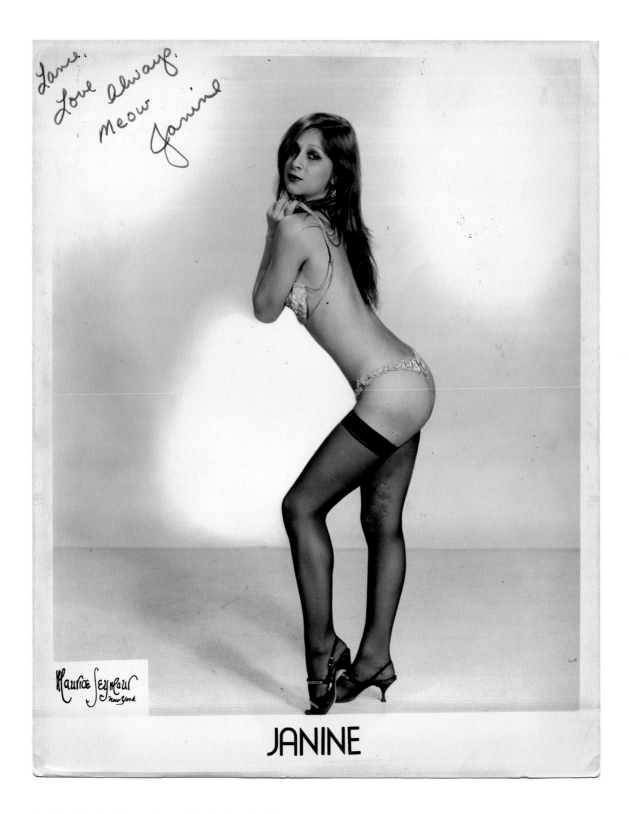

JANINE

Paul Zone introduced these strippers to the Louds and took them
to see their show in Times Square in New York. They were
followers of the Fast-Good Stories.

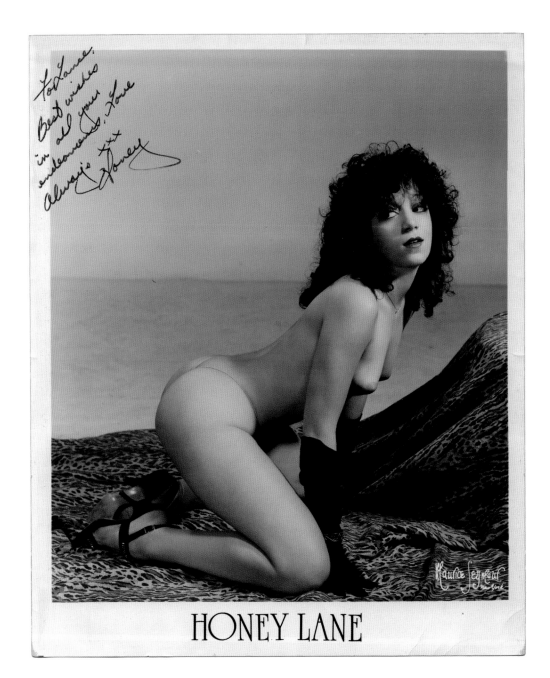

HONEY LANE

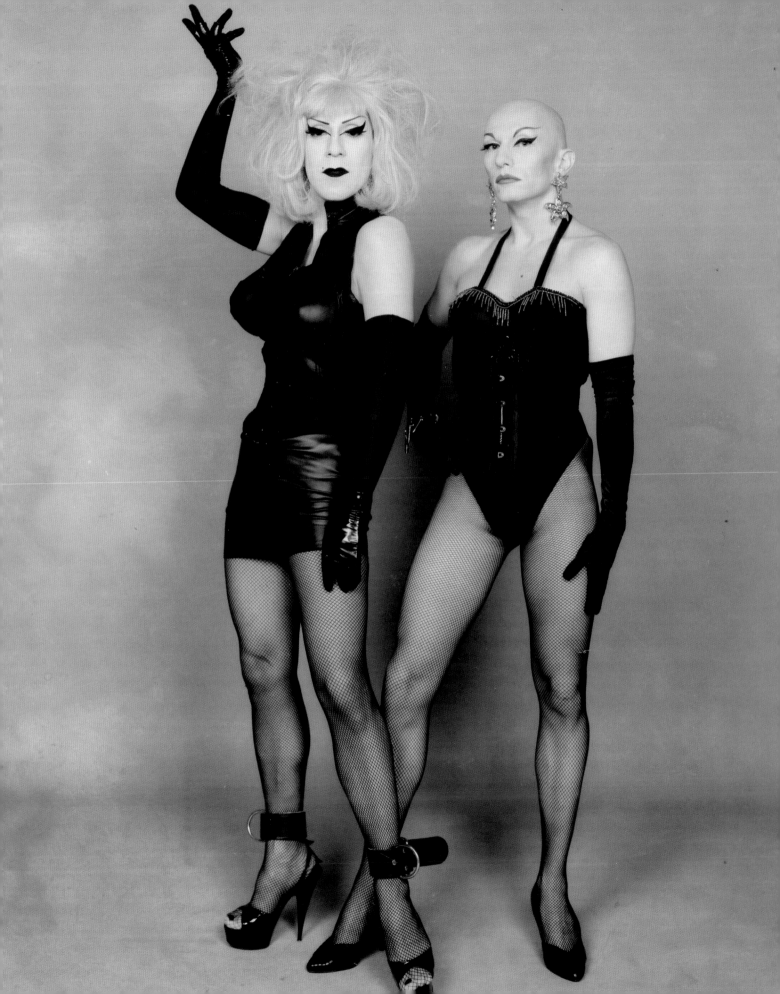

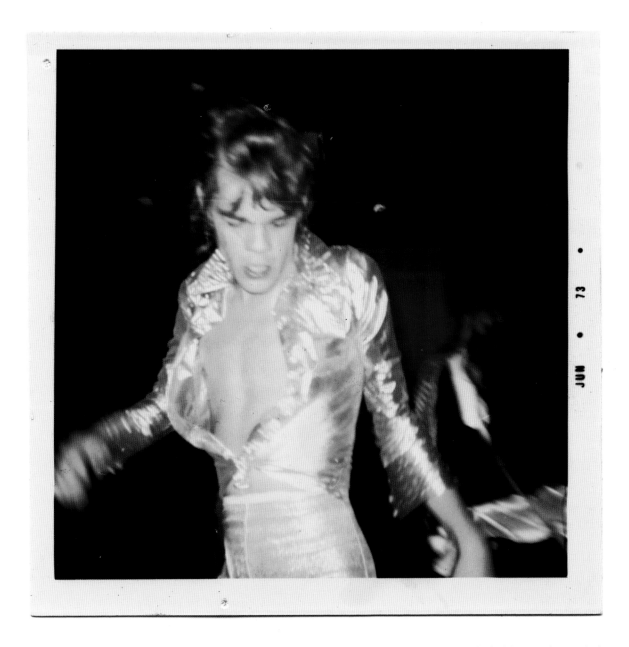

David Johansen, photographed
by Kristian Hoffman

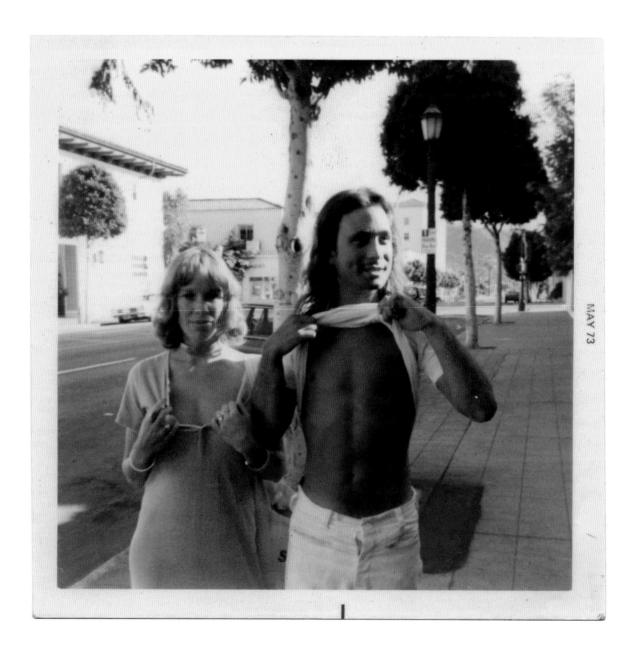

MAY 73

Melissa Rivers and Ross Bleckner

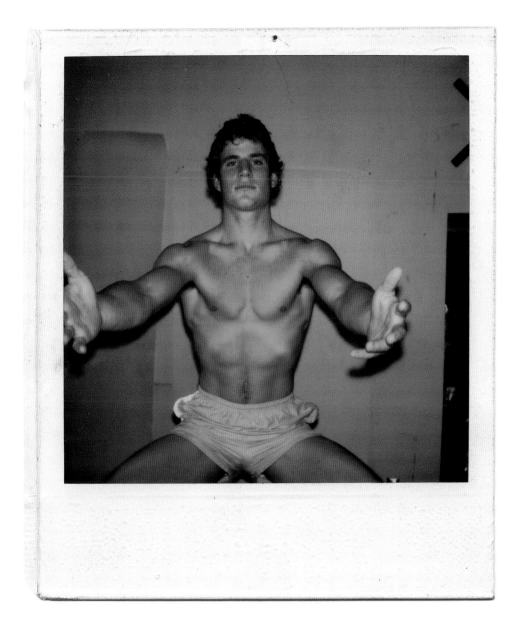

Anonymous

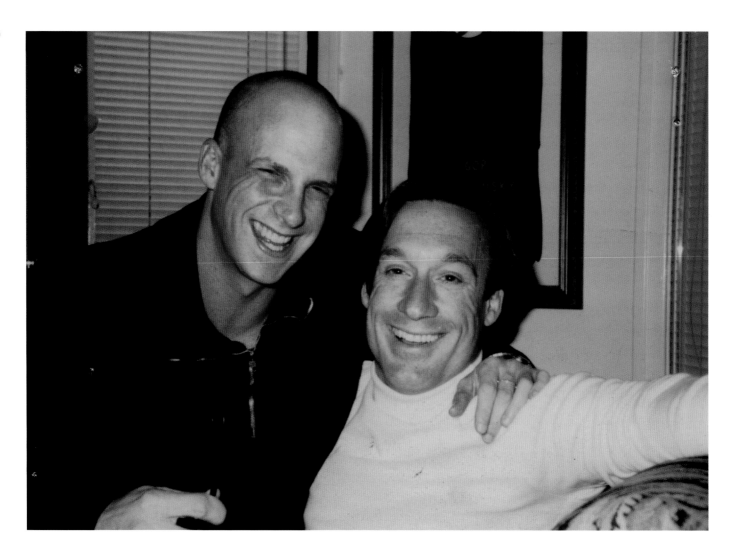

Gregory Poe with Lance

Jackie Curtis, Kristian Hoffman,
with Lance in front

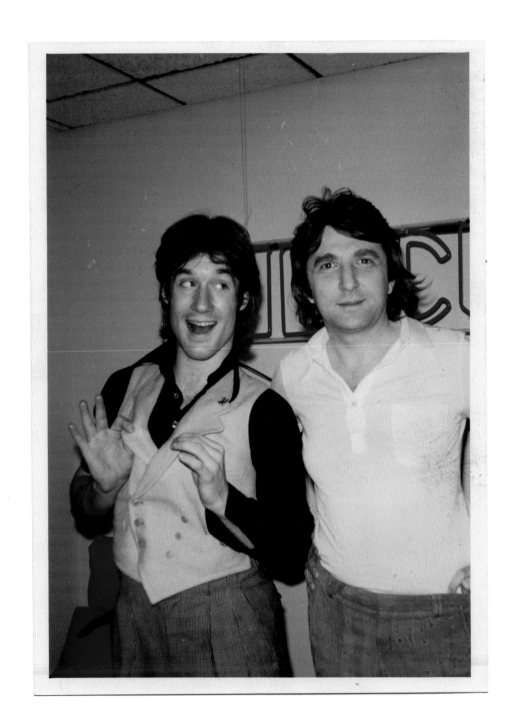

Lance with Gerry Rothberg,
editor of *Circus* magazine

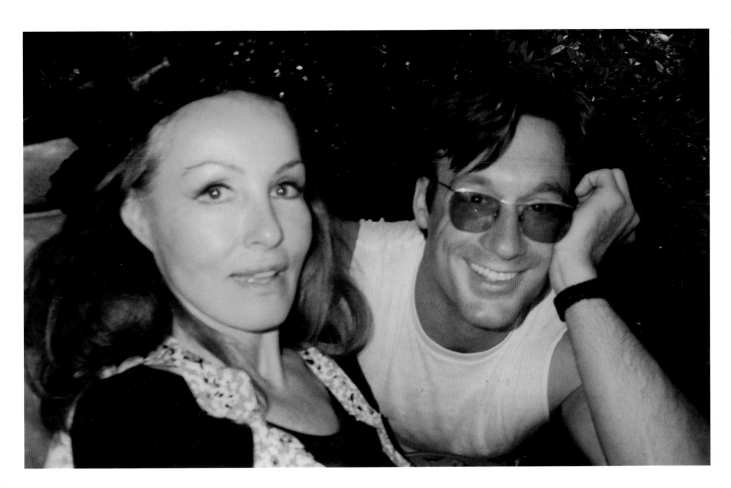

Julie Newmar with Lance

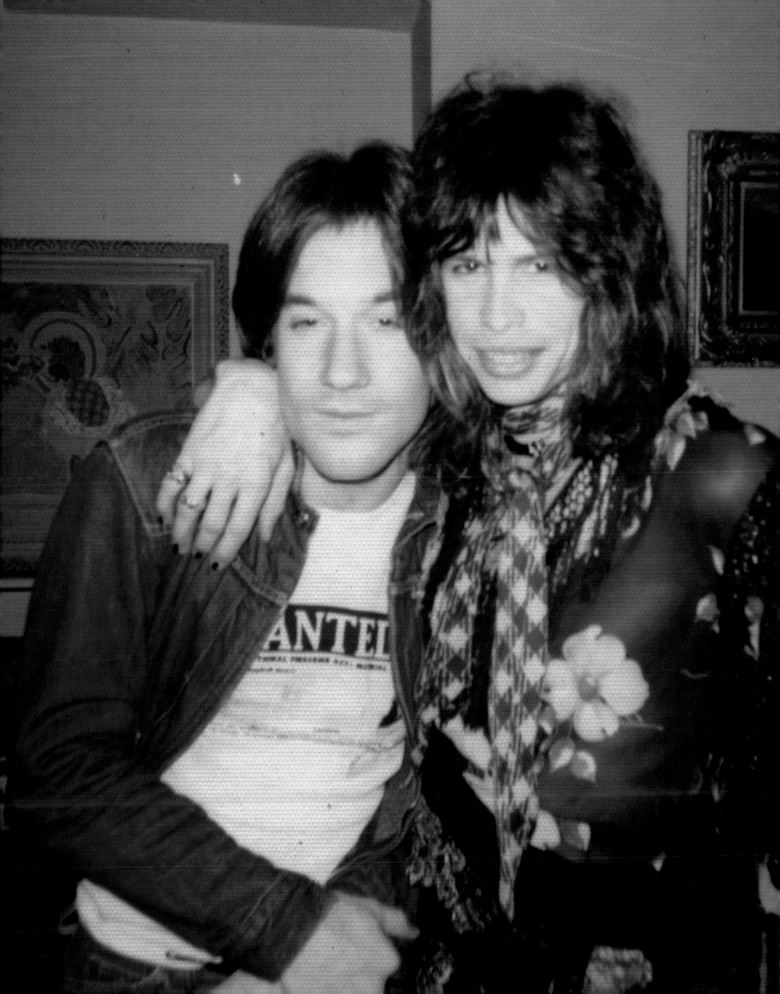

Lance with Brian Eno

Jackie Curtis performing

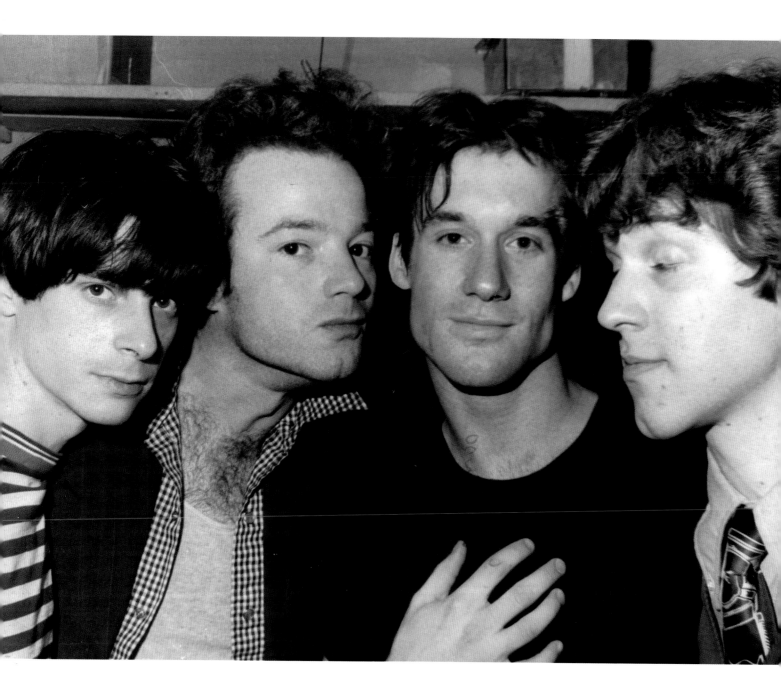

Rob DuPrey, Jackie Courtis, Lance,
Kristian Hoffman

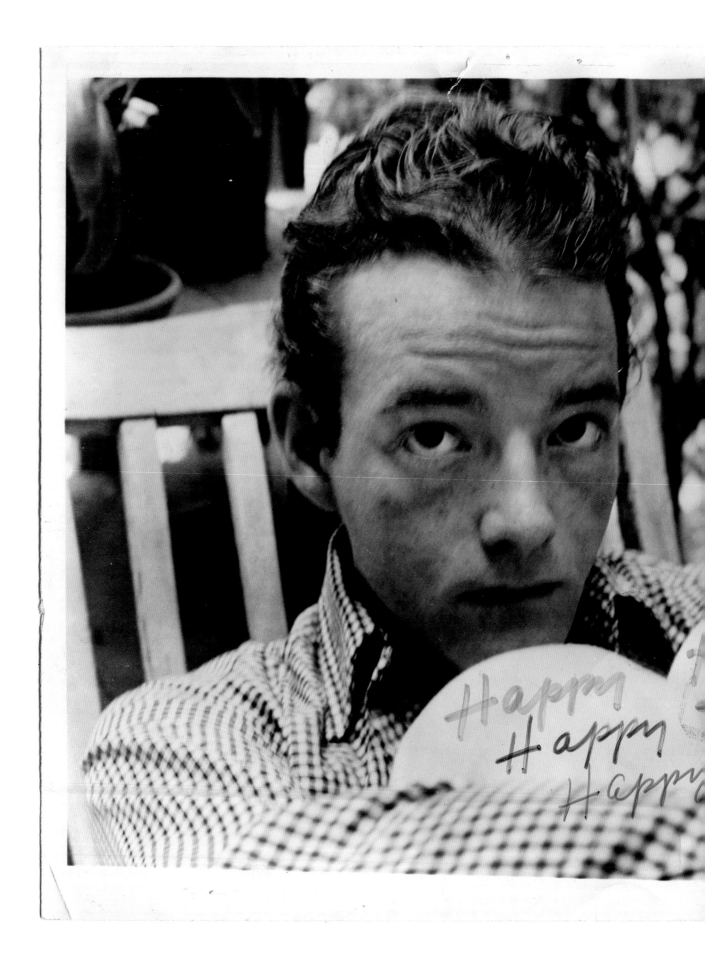

who would have thought he
have been so successful . . . that boy who
wore those glasses and was so quiet?"

Even in those days, he was difficult to
know. I remember in discussing him one eve-
ning, someone at my home said, "When Jim-
my was parking cars in New York on the
CBS lot, he was a lot happier than he was
all his acclaim in Hollywood."

Jackie Curtis

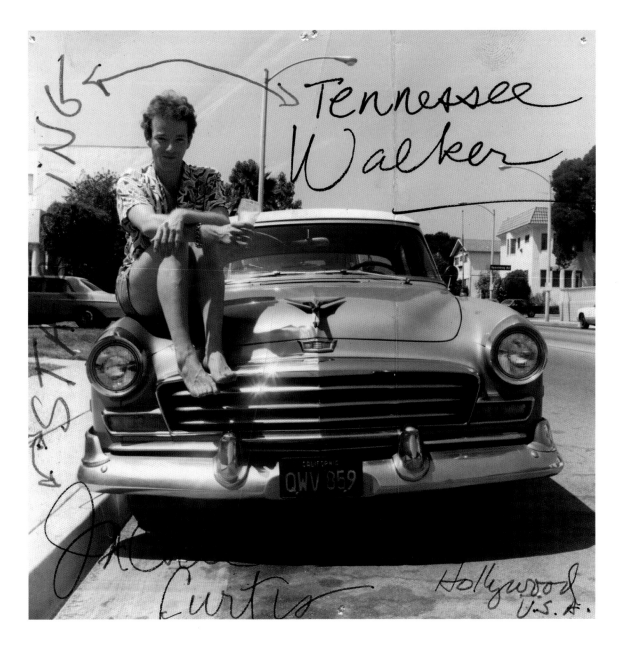

Jackie Curtis

That's How You Do It! 1974. The sound of my name yelled up from Christopher Street below and into my fourth floor window. "Lee-Sa!" cuts through whatever music I'm playing, dishes I'm washing, the voices of other friends hanging out in my railroad flat. "Lee-Sa!" Lance would holler, giving both syllables equal emphasis. Was a man ever more aptly named Loud? He sure as heck had my number. But Lance couldn't just call me from a payphone to let me know he was coming over. No, not like everybody else.

The image of Lance that lives along with that sound of him calling my name is this: his head thrown back, mouth open, sweat dripping off the back of his head and flung off the ends of his hair, jubilant after a set at CBGB—or after almost anything. Because everything Lance did, he did big-box size and to the nth degree until a river of sweat poured off of him. I see him wringing out the shirt he'd just worn into a trashcan and looking at the rest of us cock-eyed and defiant, as if to say, "That's how you do it. This is how it's done or it's not done at all."

I picture him as he was, living this life, using his up with fervor, with fever, with voracity. And laughing. And everywhere he laughs, cats spring up, and music. I scream back when I throw the keys out the window; "Hey. Lance! Catch!"

Now, put on The Kinks. "I'm Not Like Everybody Else" by the great Ray Davies. And dance around the apartment with us. Lisa Jane Persky

Left to right: Kevin Sessums, Bob Mackie and freind, Ian McKellan, Lance, Paul Bartel. Photograph by Suzanne Tenner

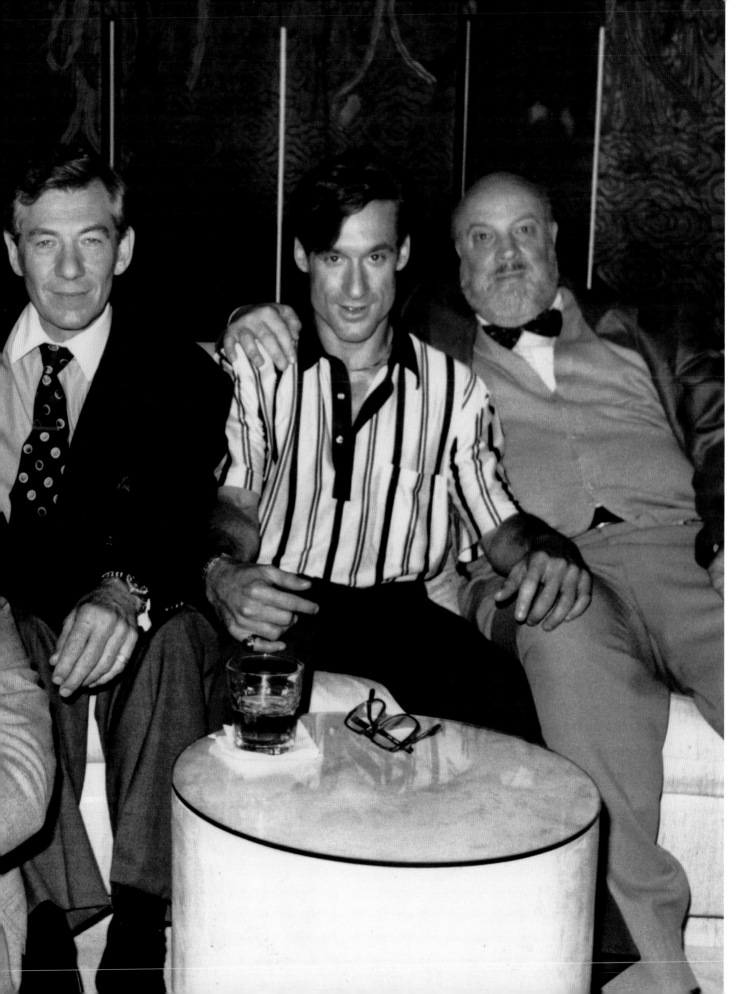

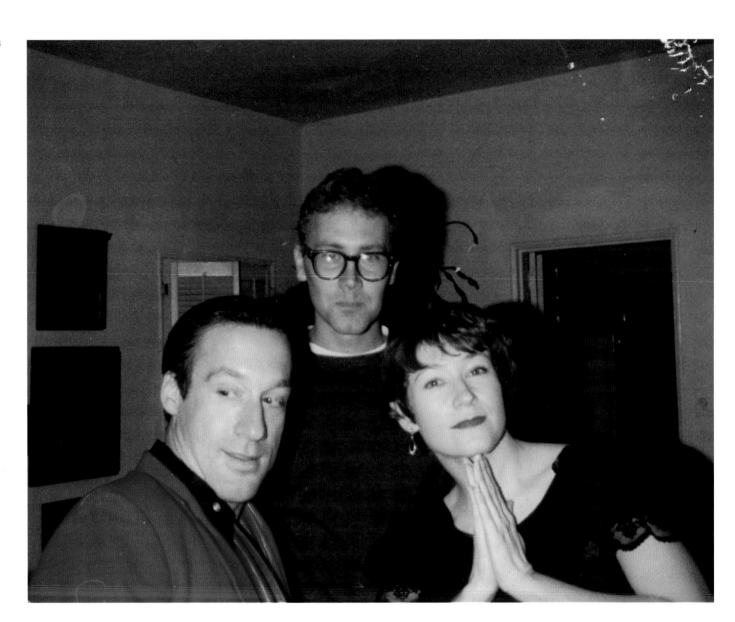

Lance, Brad Dunning, Ann Magnuson

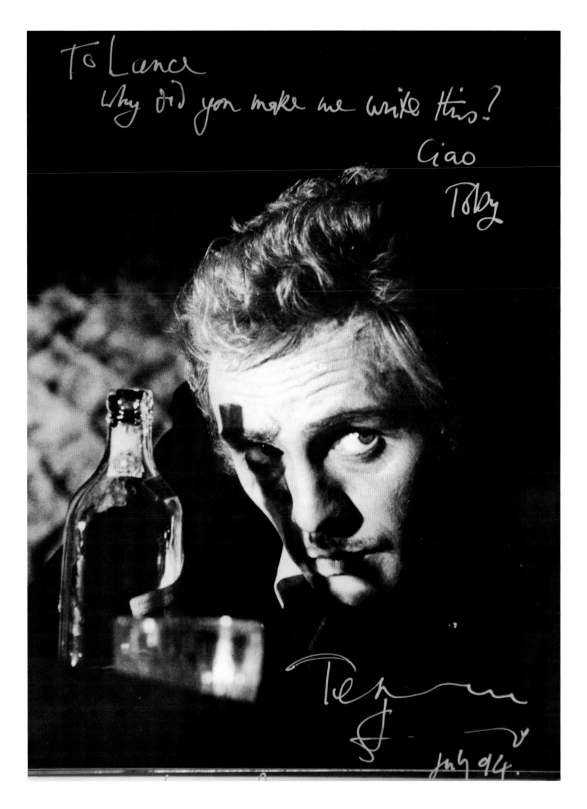

Terence Stamp

Holly Woodlawn with Debbi Mazar

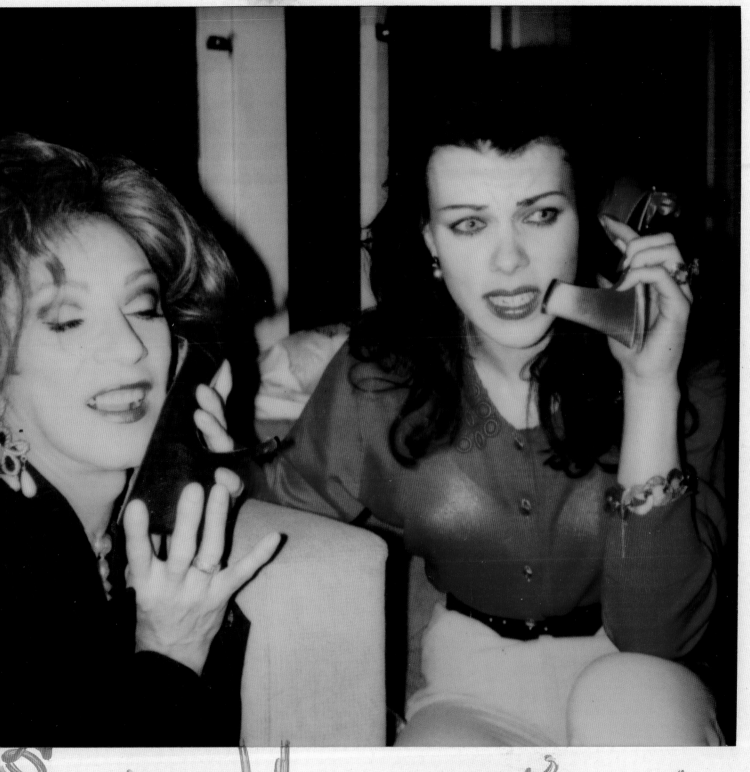

THAT'S REAL

yeah. **TOUGH!**

Shecky LOUD,
STRiKES!
Isn't it comforting to
Know that you can be
in your sick Bed and
someone can still be p
LEG! Hardy Har Ha
been a true blessing to he

POST·CARD

PLACE
STAMP
HERE

MADE IN U.S.A.
M-4

rom Lance!

g your hip... I MEAN

But seriously pops, it's

n you sound so much

BETTER LATELY. I
Love you Dad

Card from Lance to Bill,
consoling him on his hip
replacement, 2000

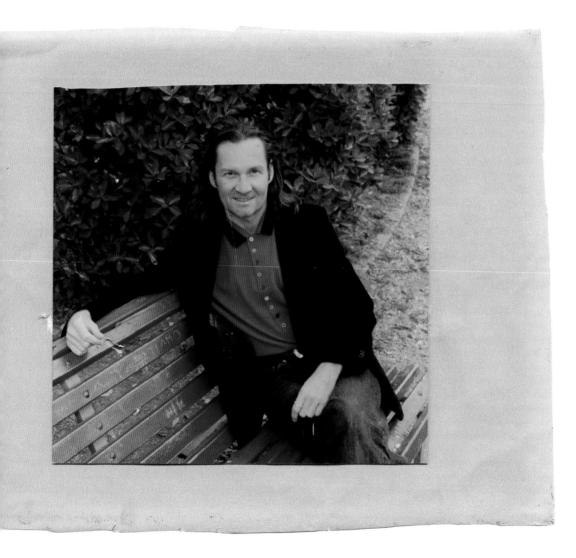

Craig Gholson

Lance with Gus Van Sant

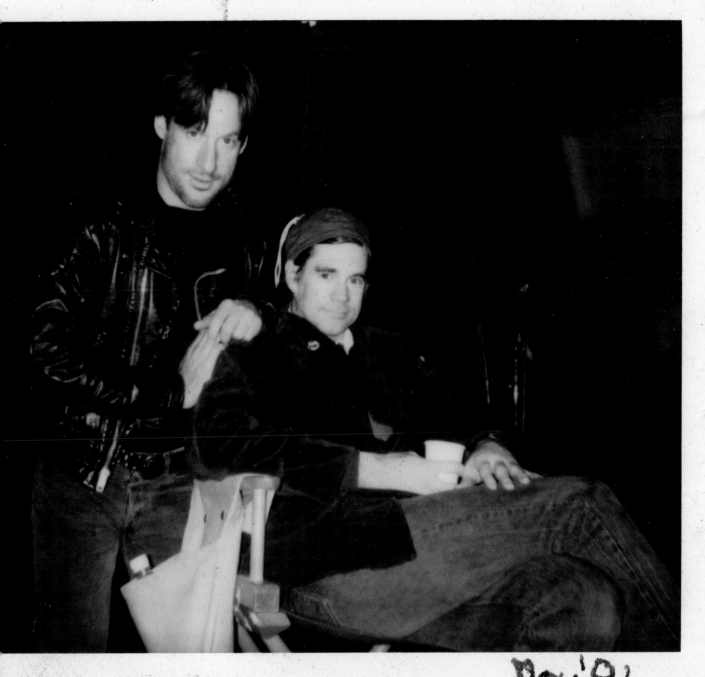

ME + GUS V.S.
on set of PRIVATE IDAHO

Nov. '91

THE Philosophy of Andy Warhol

to Lenee Load

without love

Andy Warhol

may 75

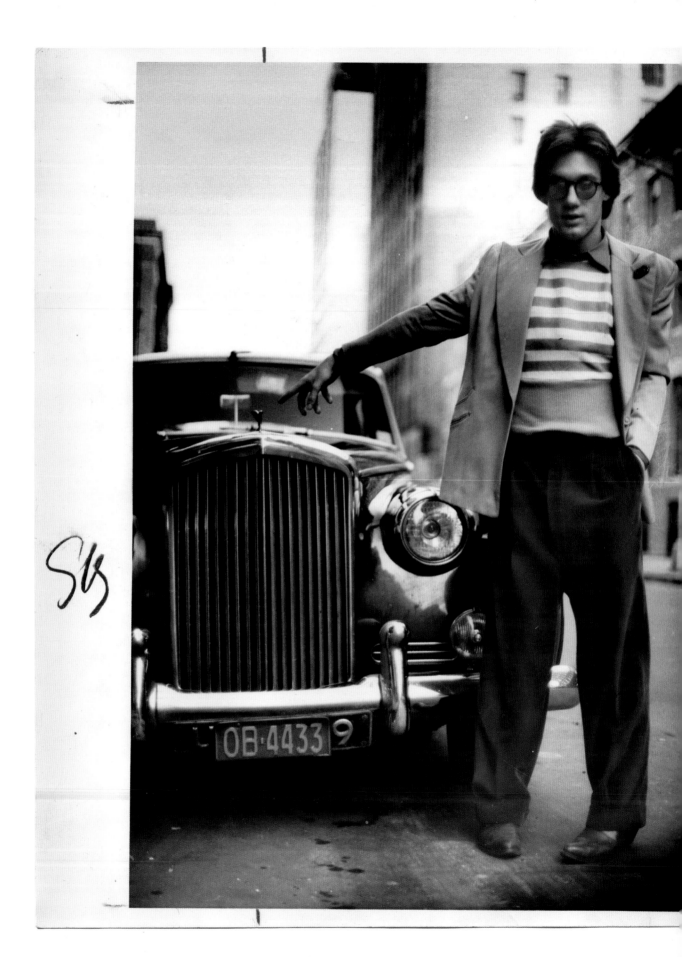

To Live and Drive in L.A.

Both living and driving are

Of all the things we do in L.A.,
driving ~~everywhere~~ in the ~~anyplace~~
precedes as the #1 pastime for
~~required~~

~~Further than Farmslengths from~~
~~and serious~~ to Angeleno. To live _is_ to drive
here. ~~those~~ Locals without transportation
are ~~viewed~~ as troublemakers and layabouts
~~who have~~
~~with~~ nothing better to do than wait for ~~a~~ buses
~~or walk for~~ Only hookers and tourists walk
here, it is generally felt. and so ~~for the~~

~~mere~~ ~~necessity of~~ driving is a must here

~~Driving is done by highway~~
~~Like a National wildlife refuge~~ — Los Angeles
~~is a haven of every imaginable~~

In L.A. every type of highway, byway, underpass
and detour can be found in its natural habitat.

May 1993	June 1993	July 1993	August 1993
S M T W T F S	S M T W T F S	S M T W T F S	S M T W T F S
1	1 2 3 4 5	1 2 3	1 2 3 4 5 6 7
2 3 4 5 6 7 8	6 7 8 9 10 11 12	4 5 6 7 8 9 10	8 9 10 11 12 13 14
9 10 11 12 13 14 15	13 14 15 16 17 18 19	11 12 13 14 15 16 17	15 16 17 18 19 20 21
16 17 18 19 20 21 22	20 21 22 23 24 25 26	18 19 20 21 22 23 24	22 23 24 25 26 27 28
23 30 24 31 25 26 27 28 29	27 28 29 30	25 26 27 28 29 30 31	29 30 31

Monday May 31 151/214

MEMORIAL DAY (OBSERVED)

8		1
9	~~Interview w/Kitty~~ in A.M.	2
10		3
11		4
12		5

evening

Tuesday June 1 152/213

8	Colleen Pal call Daniel	1
	TUES EVE Re Bike	
9	call Newman 874	2
	re) Doctor's apt.	
10		3
11		4
12	STEP Class "The Wedding Banquet"	5

evening

Wednesday June 2 153/212

8	Kenny @ interview	1
9	Kenny 10:30 at house	2
10	2620 Benedict Canyon	3
11		4
12	AMC 7:30 Century City shops	5

evening

Marcos Hu
415-4415220

Charlie

MONDAY MAY 31
thru
SUNDAY JUNE 6

Thursday June 3 154/211

8 21346090003
 6564272

9

10

11

12

8:00
Cinerama Dome
Calvin Klein *evening* whats love
got to do w/ F)

1

2

3

4

5

Friday June 4 155/210

8

9:30 w Kitty / Michael Q + A:
9 250-5959

10

11

12

"The Wedding Banquet" *evening*

1

2

3

4

5

Saturday June 5 156/209

7-11 Cra
4658752
STEVE + Craig
Party

Sunday June 6 157/208

BEN is DEAD
Party at
Al's BAR
8:00

Monday March 22 81/284

8 — get list Together for FLIRT
Mackay Cattell
9 — Richard Dupont
EZRa
10 — Bob
Kristian + Cash
11

12
Charles 310 *evening*
Bush 8551515 Rm 323

Tuesday March 23 82/283

8 — Hosting table at Flirt — call
9 — Breakfast 9:30

10

11

12

evening

Wednesday March 24 83/282

8 — 1:00 Alan 12th floor —
9 — 9:15 Weissman

10

11

12 — 7:30 Pasadena
evening

Kathy wood

MONDAY MARCH 22
thru
SUNDAY MARCH 28

Karen Hson

Eye for detail

Thursday March 25 84/281

8 MONDO + VIDEO

9 Aggie at 4:00

10

11

12 6:30 - house 1200.0

 Ann Magnuson 8:00
 evening

Friday March 26 85/280

8 11:00 12th floor Advocate

9 Alan

10

11

12 Raji's afterward
 7:30 Jack the Bear Avco Westwood
 evening

Saturday March 27 86/279

Don SPRADLINS
Party
IFP AWARDS

Sunday March 28 87/278

Oscar Party

Traffic Court
Any Day before ——— 8:30 or 12:30

ORS

april 1984	may 1984	june 1984	july 1984
S M T W T F S	S M T W T F S	S M T W T F S	S M T W T F S
1 2 3 4 5 6 7	1 2 3 4 5	1 2	1 2 3 4 5 6 7
8 9 10 11 12 13 14	6 7 8 9 10 11 12	3 4 5 6 7 8 9	8 9 10 11 12 13 14
15 16 17 18 19 20 21	13 14 15 16 17 18 19	10 11 12 13 14 15 16	15 16 17 18 19 20 21
22 23 24 25 26 27 28	20 21 22 23 24 25 26	17 18 19 20 21 22 23	22 23 24 25 26 27 28
29 30	27 28 29 30 31	24 25 26 27 28 29 30	29 30 31

SANTA MONICA

Monday April 30 121/245

4 Blocks w San
Diego
Freeway

8 Call Reader
 Weekly
9 Moms friend
 Fotog & Billy
10 ROSEMARY SEZ:
 SHAVE Beauty Supply Store
11 HAIR STUS SPRAY on Black
 FAKE SIDEBURNS
12 get
 CREDIT FOR HER evening

Tuesday May 1 122/244

8 ELVIS COSTELLO 4/KH
9 Call Perdue W. LA TRAFFIC office
10 Call UCLA- 8259412
11 Call USC 'LARRY EPOLITO
12 Call Reader, cancel Sci-Fi STORY 2885082c(?)
 Call OUTRIDER RE: REPAIRS CANCEL THURS
 Get Glasses stores REHEARSAL
 CALL AMBER RE: CRACK UP

Wednesday May 2 123/243

8 Call Attorney w/ Name of
 Gatherson
9
10
11
12
7:00 Photo session evening ROCKSTAR

WEST L.A TRAFFIC COURT
4794271

P103

Thursday May 3 124/242

8 GET 2:30 Fashion Illustrations
9 SPanish Exam Imp Joeseph Call
 RE Dinner w: Sparks
10
 JUKEBOX
11 Call THURSDAY 7371717
 MARSHA MODEL # of machine on BACK
12 GUITAR ANN'S OPENING Robertson
 NO FOTO'S evening GRACE REHEARSAL + MELROSE
 7:00

Friday May 4 125/241

Tom 9:30
8 LA Traffic Court Hill 54
 Call East? JUKEBOX 7371717. marsha
9 JUSTINE ?
10

11 6:30
12 The GRill w/ DAD in Bev. Hills
 GRANTS B·DAY evening DAYTON café
 WILSHIRE RODE

Saturday May 5 126/240

GRANT HOUSE
 PARTY 6:00

2-5 REHEARSAL
6:00 GRANS
9663593

Sunday May 6 127/239

DINNER w/ ANDY

Rehearsal

AT·A·GLANCE®

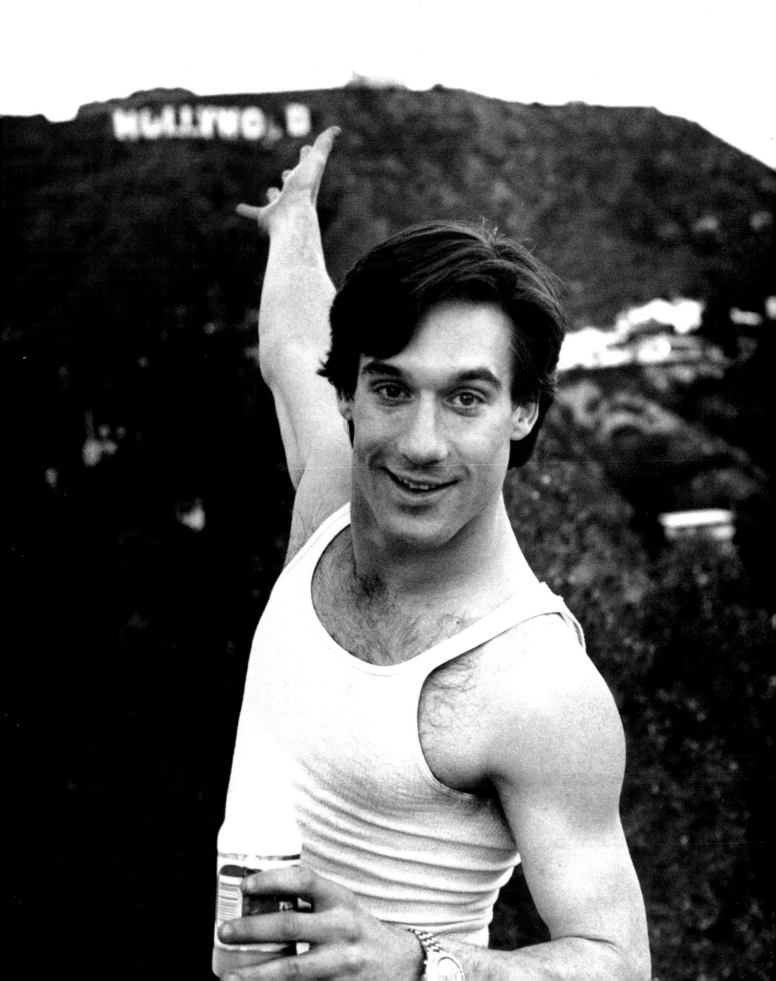

Breaking the Ice. He was best at certain kinds of journalism that revolved around pop culture and its critique and talking to people. He was a brilliant interviewer. A lot of the time he would just walk into a room and they knew who he was. And that was a unique way of breaking the ice with celebrities because they had seen him grow up on television.

He was one of those people who are great at collecting material from a variety of sources, putting it together in an oral history. We developed that into a magazine format. Lance did a number of these for *Details* magazine.

One was "The Making of Blade Runner" for October '92. Because I knew Lance personally I could actually hear his voice in my head when I read the pieces. So I could hear the turn of a phrase, the slight sarcasm, the rush of words, the kind of thing that he did so well, the way he expressed himself.

I think the cautionary tale that his life tells is of fame. When it is placed upon an ordinary person's shoulders he can respond in any number of ways. Because he wore fame and he wore being a role model and he wore being a gay man, he wore being a brave soul like it was a piece of chiffon when, in fact, it was a really heavy piece of armor for him and it weighed a lot. It was very difficult. He never really showed it but I think it was difficult for him to be that person and to trudge through life when it had been made so easy for him in the beginning. He was a force of nature to be reckoned with. By the age of twenty he had done his masterpiece. He had created it by merely existing and letting someone capture it on film. David Keeps

Lance photographed by Rob Sheiffele

Curious and Terrific. Lance was one of the most curious and terrific kids around and I always told him that he had the best band around, called the "Mumps." I hated it that he quit so early and left the Mumps behind. Andy Warhol

UMPS

starwood

unday nov 27

western union

YSB115 (1735) (1-035418C035) PD 0

ICS IPMBALA SNC

01078 SANTABARBARA CA 13 02-04 230P

PMS KRISTIAN HOFFMAN AND MUMPS

TRUDY HELLERS 9TH STREET AND 6TH AV

NYK 10003

DEAR MUMPS START AN EPIDEMIC AND KN

DEAD AN ARMFUL OF ROSES

NINA

NN.NN

Telegram

04/75 1734

ST

NFL

K EM

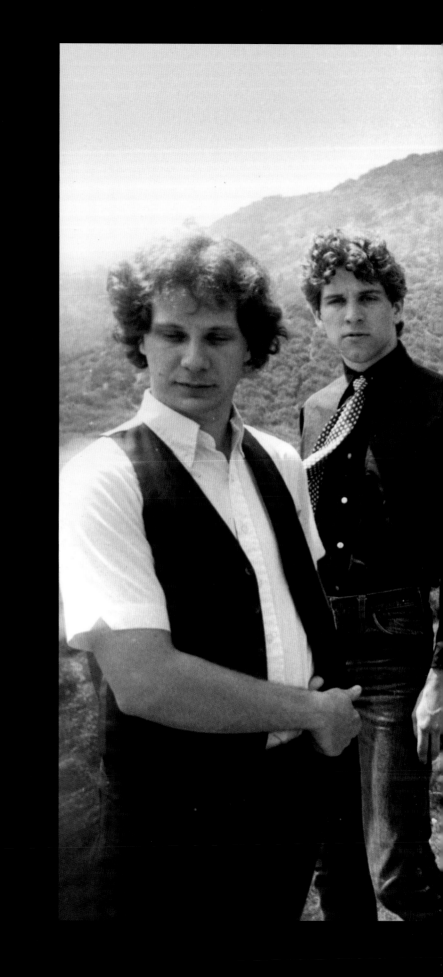

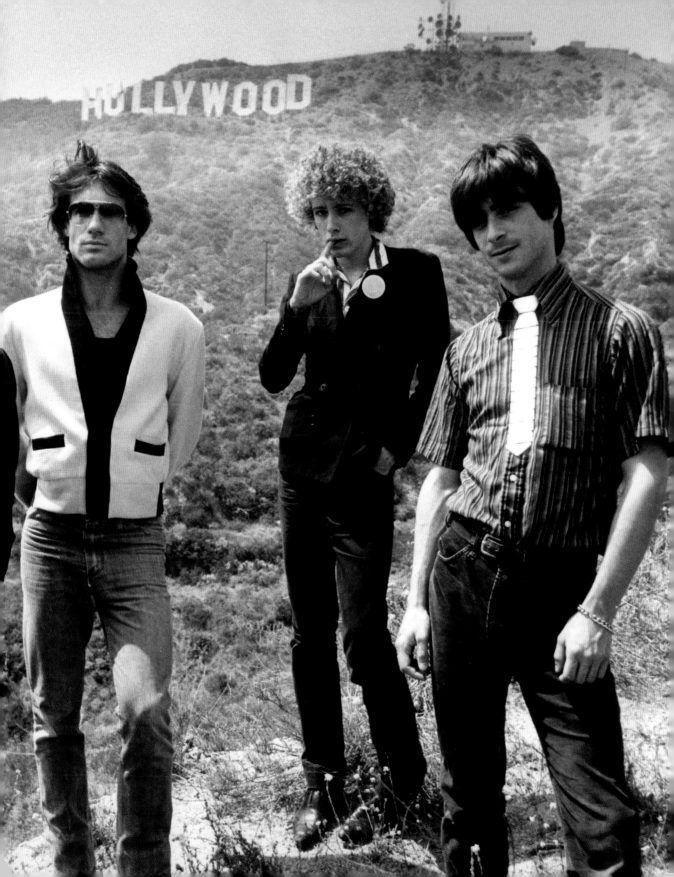

The Time of Our Lives. My favorite Lance memory is of singing Neil Diamond's "Cherry Cherry" with him and both of our bands (his was the Mumps) on stage one night at Trude Heller's in New York.

We were totally unrehearsed, lyric-challenged and off-key (or maybe that was just me), but we were so gung-ho punk, so high on the music and our dreams (and a good deal of drugs as well, no doubt); we just had the time of our lives. I can never hear that song without thinking of the unabashed exuberance, the hummingbird-like energy of Lance and of that long-ago rock and roll night. And I'm so glad about that. It was a moment when we were both so ferociously, so vibrantly alive. Cherry Vanilla

Photograph by Herb Wred

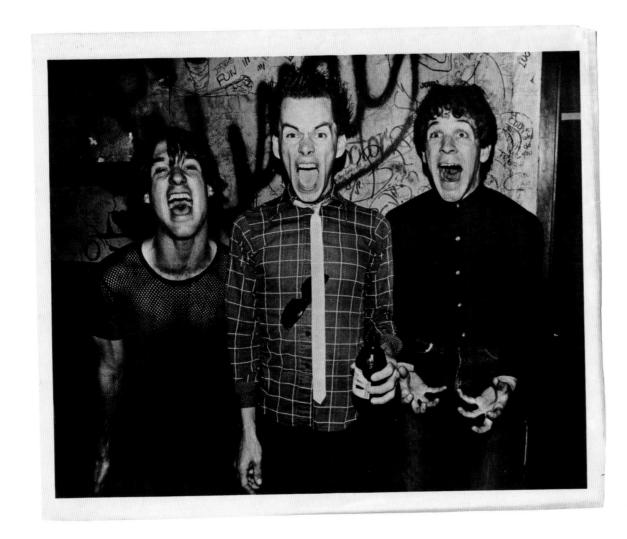

Lance, Tomata du Plenty of the group The
Screamers, and Kristian Hoffman

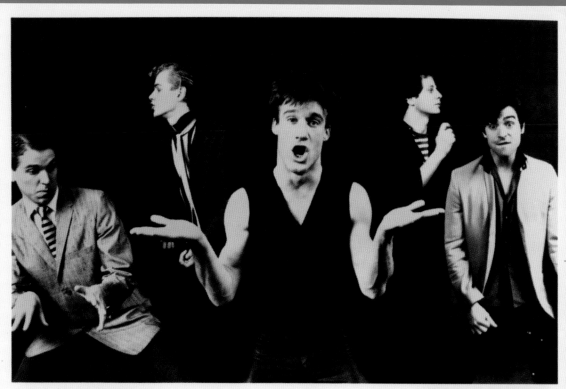

eggBERT
RECORDS

Kristian Homan, Kevin Kiely, Lance,
Paul Rutmer, Rob DuPrey

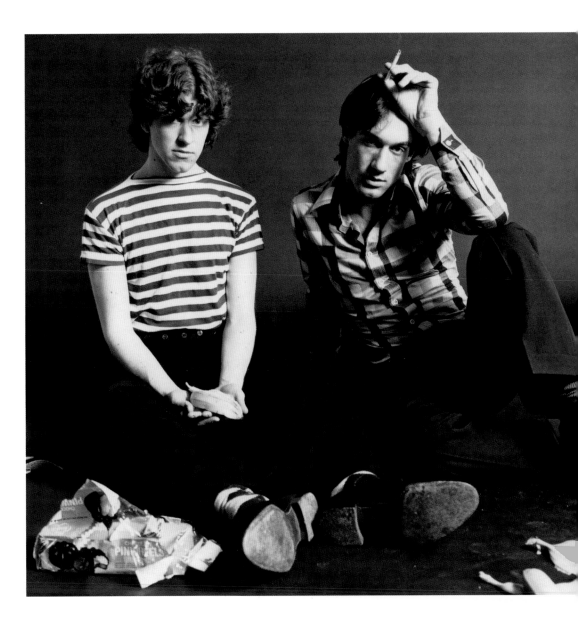

Kristian Hoffman and Lance photographed by Don C. Hanover III

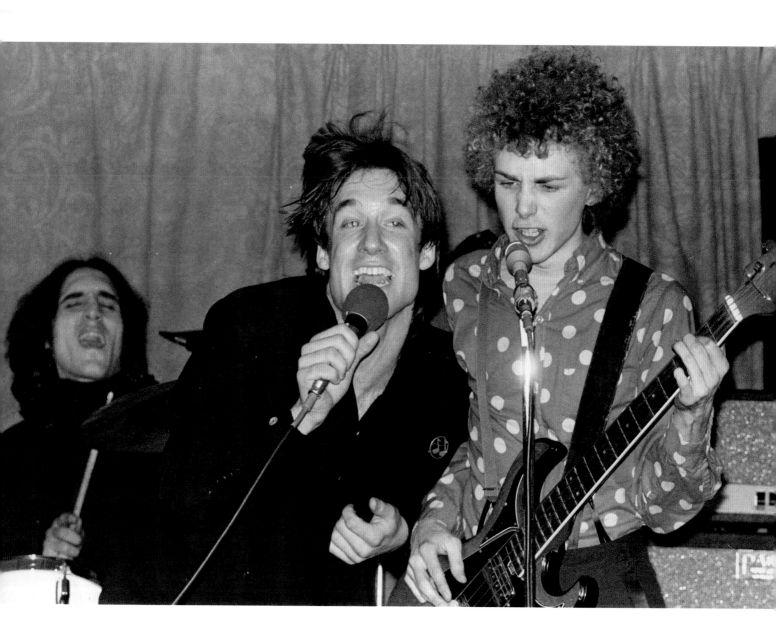

Kristian Hoffman and Lance photographed by Don C. Hanover III

This is me during
a performance —
the second song,
Pig! Did you
. ; in ~~the~~ a r
are
of Playboy Ma
they wrote ab

after only

sweat like a

now that we

...ent issue

—no fate but

2 paragraphs

Sweaty Celestial Body. It's 1974. On a tiny stage in the damp-ashtray and urine-infused atmosphere of CBGB's, the band is crashing away in a raucous high-octane power pop groove, the front man is careening around the stage, a sweaty, celestial body in a fishnet T-shirt, singing about how he likes being clean.

That was my brother Lance, a restless force of nature who refused to be pushed aside in a world he deemed almost too boring to care about. Almost. But in reality he cared more than he would ever admit. He was highly intelligent, demanding, needy and tenacious. Lance loved us and famously remarked, "Television ate my family."

But that wasn't even remotely possible because he was the carnivore, eating the ridicule and scorn to throw it back in the faces of the phonies, the put-down brigades and the hypocrites. We all stood together and never looked back. He said that for the people behind the cameras.

Lance loved movies, food, music, fashion and anything with a horizontal stripe. He adored cats and was unique, always true to himself. Never seduced by fame, he wore it as a loose garment. Many considered him an icon for coming out on TV. Those who believe that have it backwards; Lance was too impatient to wait for the rest of us, so he ran ahead and scouted the rapids to tell us that the water was fine.

At the end it was my mother, my sister and I at his bedside as he moved on to the next big room. Afterward we cried together and stood outside in a cool and crisp Los Angeles winter night. I looked up through my tears to see a giant shooting star careening horizontally across the sky, a fantastic and sparkly celestial body in the beautiful starry night. Delilah Loud

Photograph by Kevin Kiely

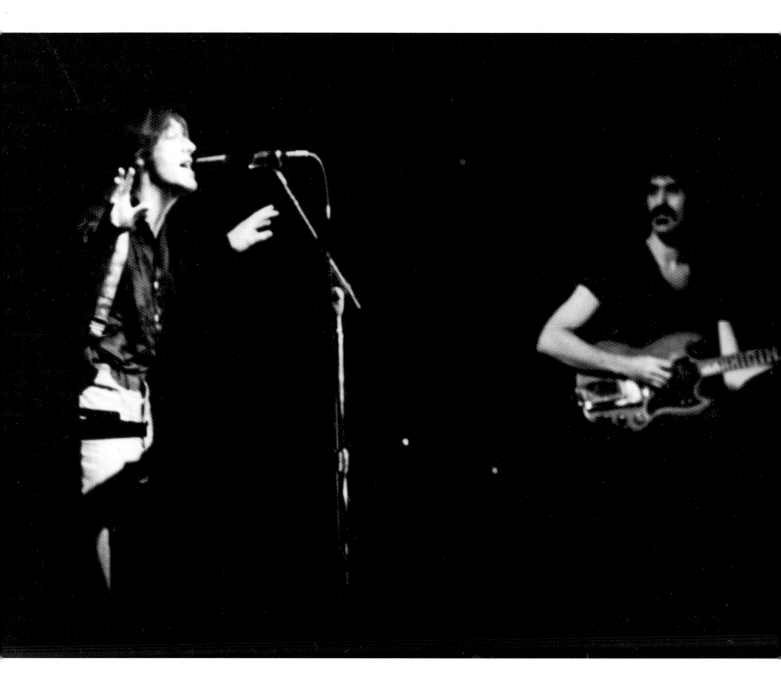

Lance with Frank Zappa

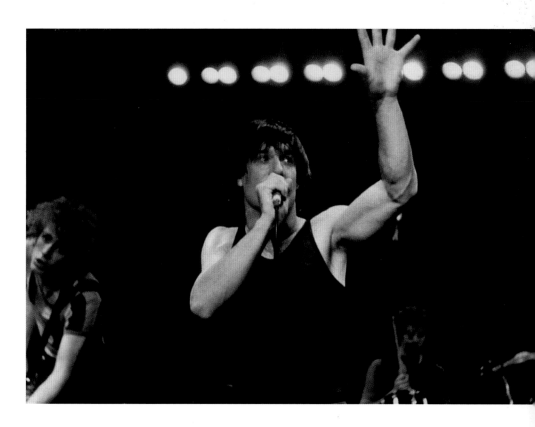

Kevin Kiely and Paul Rutner performing
at Starwood in Los Angeles

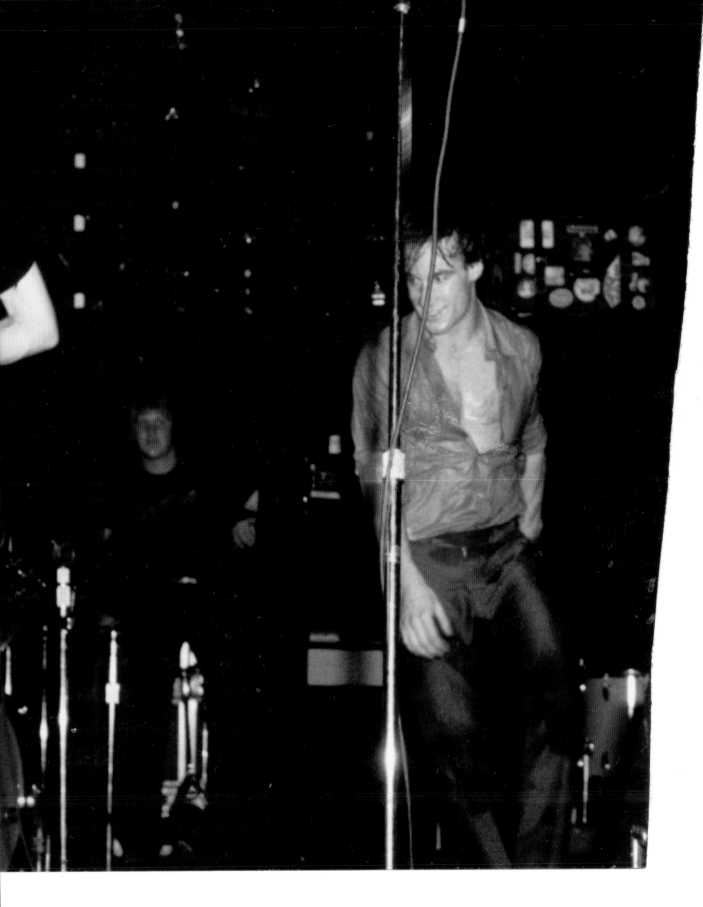

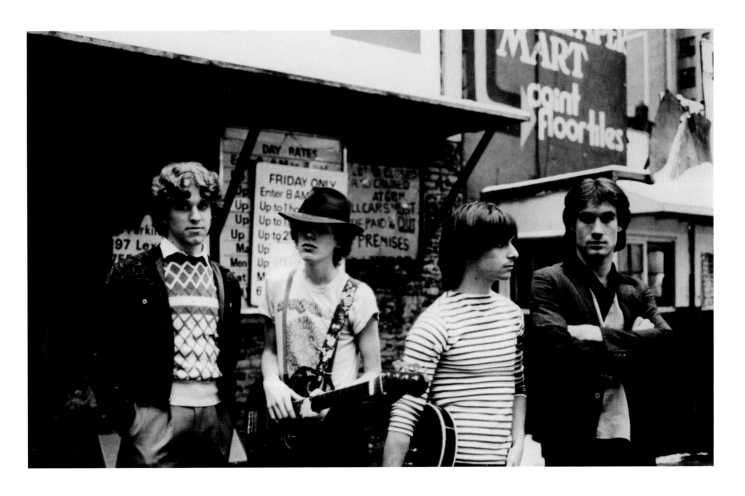

Kristian Hoffman, Kevin Kiely, Rob DuPrey, Lance
in a photography by Lisa Jane Persky

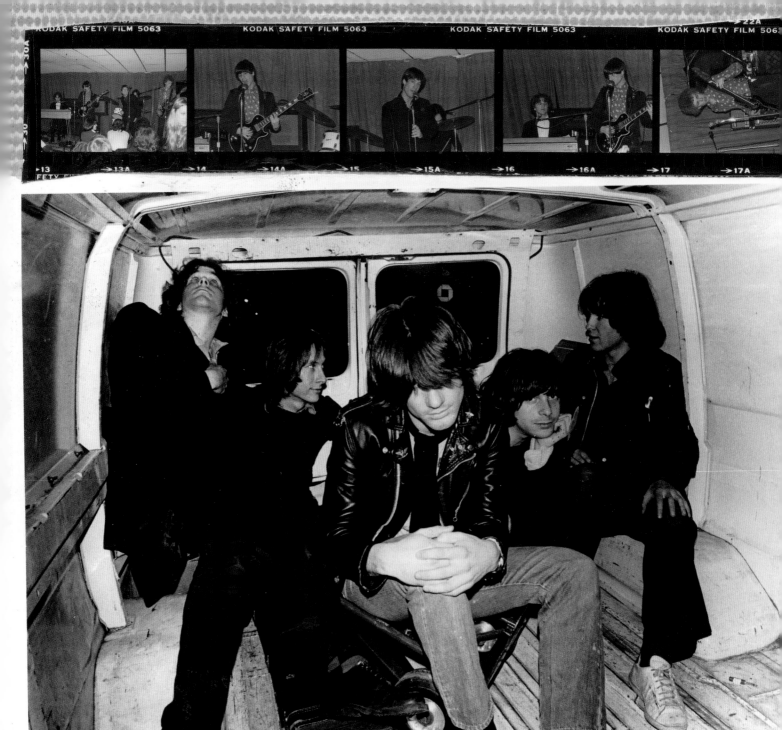
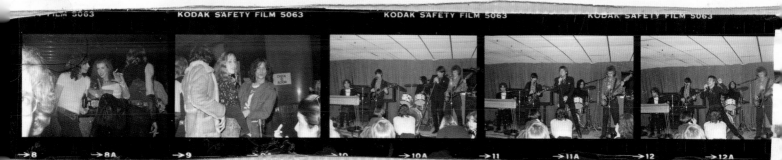

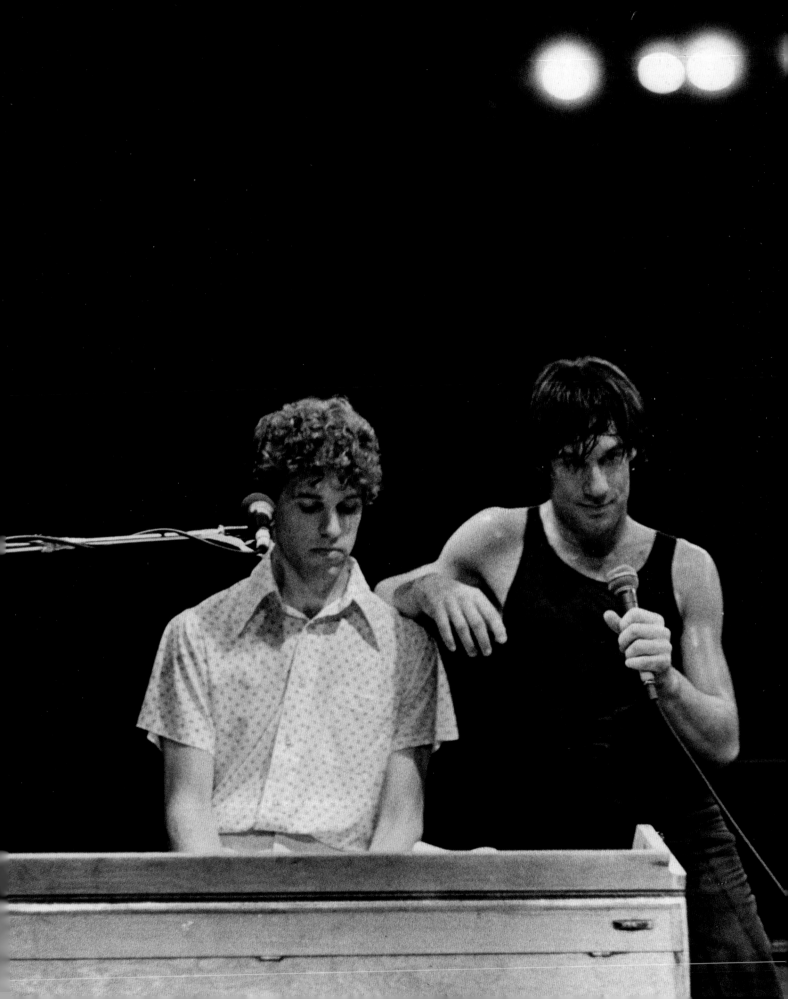

P126 Kristian Hoffman, Jay Dee Daugherty, Lance, Rob DuPrey, Aaron Kiely

P127 Kristian Hoffman and Lance

P128

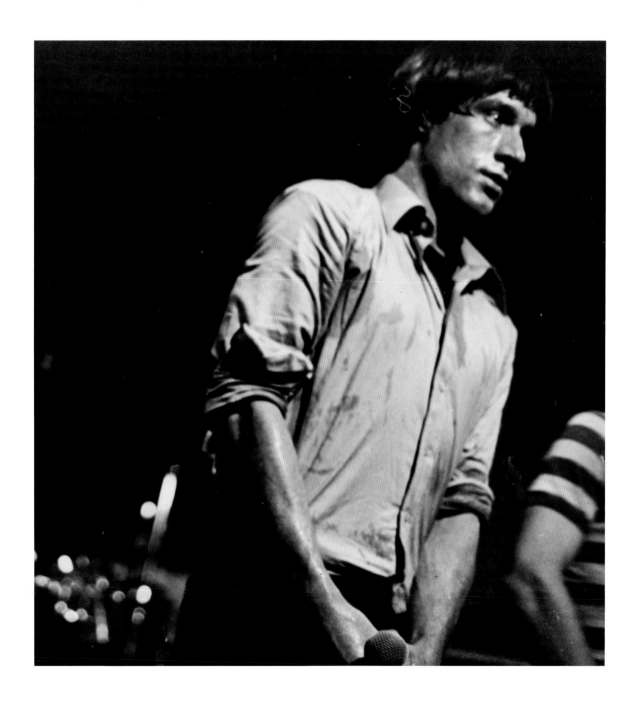

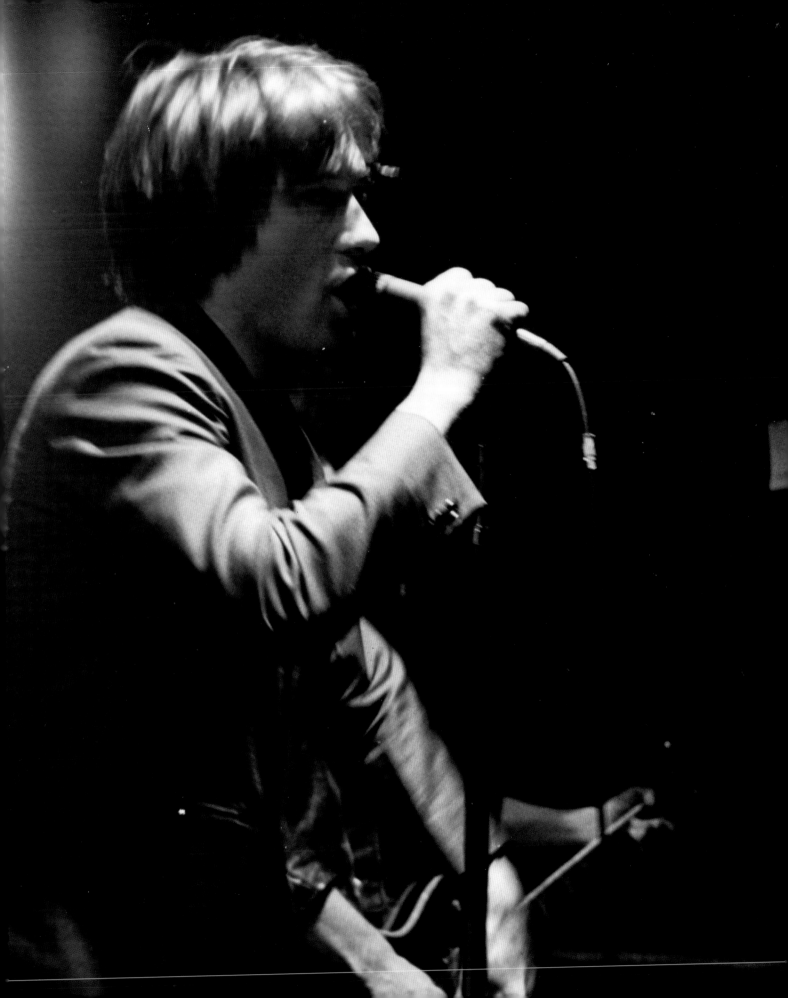

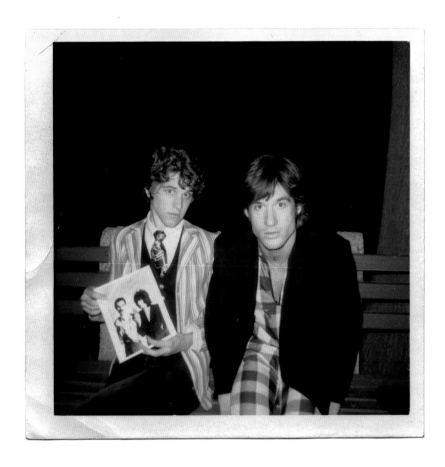

Kristian Hoffman and Lance

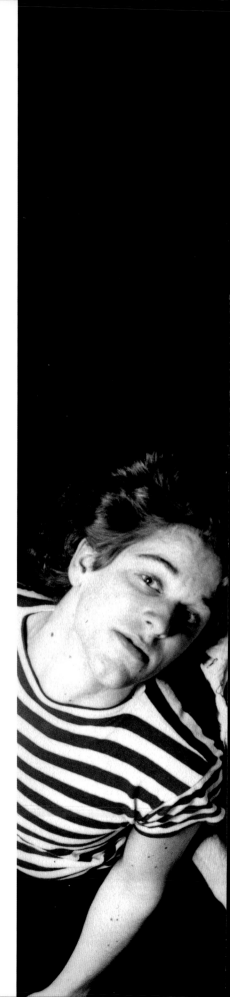

The Mumps: Kristian Hoffman, Jed Plane, Lance, Kevin
Kiely, Rob DuPrey, photographed by Don C. Hanover III

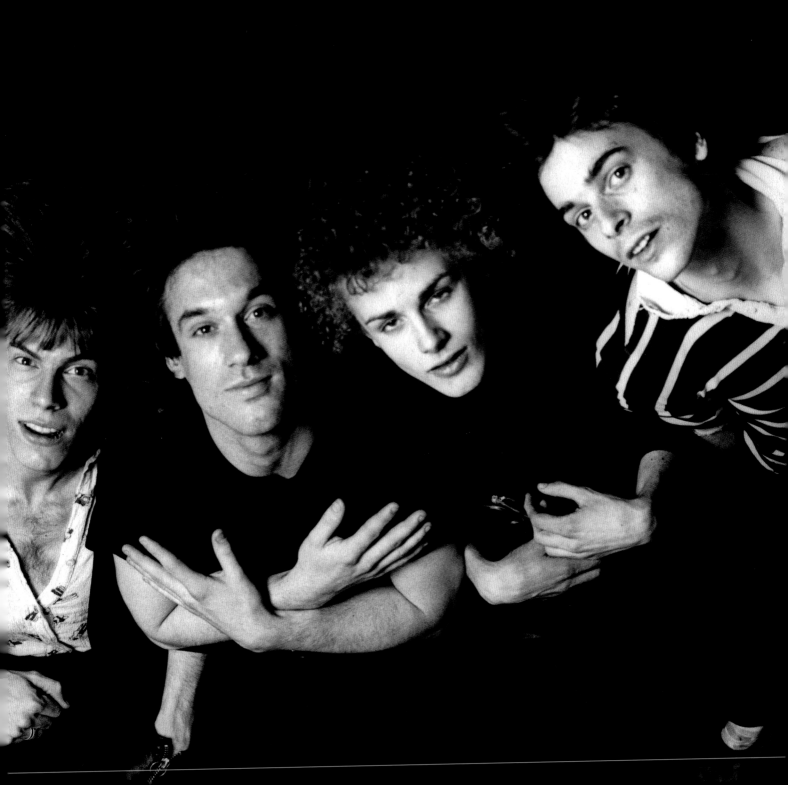

Dreams of Glamour. Lance was someone you always wanted to impress.

One of his favorite sayings was that the greatest sin known to man was not murder, rape, thievery, suicide and certainly not sex. No, these were all vivid colors on the canvas of life.

According to Lance the greatest sin in the world was to be a bore.

So, it was with this requirement in mind that back in '97 or so I was to meet him at a Halloween party in West Hollywood. I suppose that the general Robin-from-Batman outfit with bright tights and a skimpy top would have sufficed, thus appeasing both the lascivious gay We Ho scene and Lance's decadent sensibilities, but no, I had to up the ante, I had to impress Mr. Loud.

I decided to go dressed as an exaggerated version of a Strawberry Shortcake doll, with mountains of pink curly hair crowned with a bonnet, exploding bloomers, and a serious rash of freckles, in red high heels and striped tights. I really worked a long time on it and by the end I truly looked ridiculous.

But that was okay. Lance had earlier effused that everyone would be there and everyone, including himself, would go all out in the costume department thus engendering a kind of battle of the garbs.

Having witnessed this gauntlet dropped, my hunger was aroused and I of course had to be the champion of this wild and exotic Tinseltown ball.

Anyway, looking like a combination of Bette Davis on acid and Little Orphan Annie on speed, I arrived at the party and quickly noticed that except for a very demure and gorgeous Ann Magnuson dressed as Lady Di with wings, and Lance sporting a turtle neck decorated with a piece of white tape (a priest???), everyone else basically had eyeliner on or maybe if adventurous, a streak of brightly colored hair.

I felt a little overdressed, which at a Halloween party is not a good predicament.

Perhaps this little story says more about me and my propensity to run away with my desire to impress, or LA's tendency to over-blow a situation, but us movers and shakers in the world need a spark to ignite our ideas and be it silly Halloween costumes, songs and at this point several motion pictures, for anyone with the imagination to listen, Lance had that unique power to motivate and inspire, Even if at times it was leading you over a proverbial cliff.

Thank you, Lance—for all the dreams of glamour. Rufus Wainwright

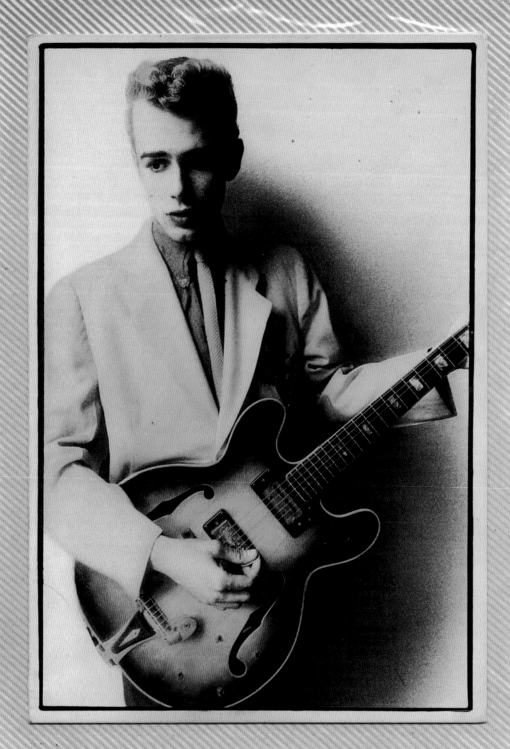

Mump's Bassist
KevinKiley makes
it big...

as a greeting card!

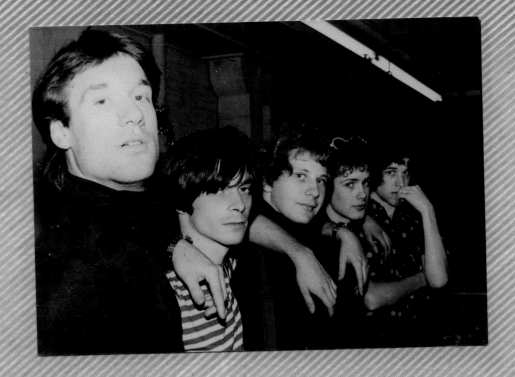

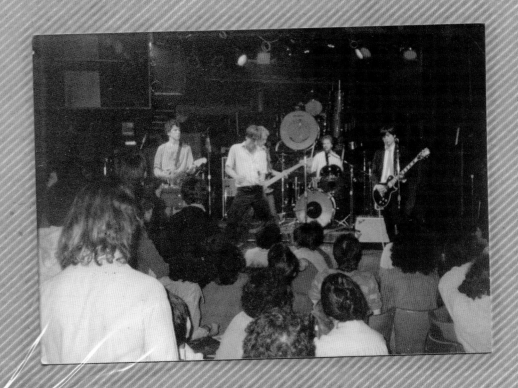

Lance, Rob DuPrey, Paul Rutner, Kevin Kiely, Kristian Hoffman
Performing at The Whiskey Performing at The Whiskey

LL; Does it make any difference to you who does your hair and makeup. Do you depend on them or their opinion of how they make you look?

AS: First of all, it's not much my decision in how I look. It's the director's decision, really. And what I think is important is that the department head of makeup and hair people have to be in tune with what the director wants. Then, you know, I'm in those meetings with themand we talk about it. Then what is an advantage of having, first of all, guys that are very creative and very good is that they can make you look goodwithin that framework. Even though the hair may be wet or if the makeup is supposed to be screwed up, you know, with blood all over, it has to look real. And also, what we are trying to do is, in my case, is look somewhat different in every film. So when you have,.. I' have decided a long time ago that WHEN Jeff (Dawn) and Peter are perfect for me because they are hard-working and very creative and they always go beyond the job--with the research thatthey are doing and all this stuff and with the contacts they have in helping them, if it is someone building a wig or building a mask or something like that, they are in touch with the best people in town or in the country, if necessary. Because they gobeyond their regular work of coming in at 7:00and just doing thier job and running home. I mean, their work continues many times after that and on weekends. They have to putall this stuff together. The advantage is, when you have people like this who are very good, to have them continue, then, on every movie because they are aware of what the variousdifferent looks were, in past films. So when the director says, "Well, we'd like you to have, you know a crew cut." Then they

can come backand say well, he had a crew cut in COMMANDO
and he had a~~xcrew~~ semi-crew cut in PREDITOR and maybe
we should come up with a different idea. So you know,
maybe they can put something in there in the discussion
and the creative development because they have been on
many movies with me before. So that's a big, big ad-
vantage for me. So this way, I don't have to get in there
and start thinking creatively in that area because I'm
one of thoseguys who doesn't want to get involved with
someone elses job, or interfere with someone elses job,
if it's wardrobe or hair or makeup or whatever it is.
I let them do it. That's why it is important that you
have good people around you and and then you never have
to think about it again. And Jeff and Peter always have
proven to be ready on Monday and always done a great job
and always gave me a great look. And that, tome, was
always very important. Then, of course, there is the
other dimension which is, that you want bo have people
that you like working around your face all day long.
Like as human beings. They are your friends and that
you can have fun with while youfre sitting in the make
up chair and both of themhave really great personalities.
They're fun, and both of them are working out and into
sports, and the same type of things that I am like to
do, the same conversations, the same interests so all
this together makesa great package because you spend so
much time ~~together~~XX with those fellows throughout the day.
They always have tospritz you down or put someblood on you
and make you up and all of this stuff and
~~andphekthetuyou nadlilgthialsagfwith~~ you've got to have

people that you really get along with and that you respect.
All of those things is thecase here.

LL: As you say, they are always in yourface on theset. Is
that just an annoying thing that you just get used to?

AS: In many cases, it's only annoying -- especially in the
films I do -- because makeup goes beyond just regular makeup.
I mean, if you think about PREDATOR, where he had to put
on -- all nightlong-- mud on my whole body. And it was
at a time when the temperature during the night was
extremely cold in the jungle of Mexico and you're out there
with a naked upper body and you have someone slap this thing
(mud?) on. So what happens then, because it'sso torturous,
the whole thing, and you're freezing continuously, you're
shaking continuously. That goes on all night . Jeff is the
kind of a guy who will adjust to that and will know how much
I hate it and ~~then~~ then ~~then~~ will add on to that and make me
hate it even more, so he will add his own personality to it
and say something like "Okay, Arnold, here we go. I am
really going to make you freeze. I'm really warm now. Look
at my down jacket. I'm really warm now,", then vroom, he
throws this shit on you. So that makes it funny all of a
sudden, because he gets an enjoyment out of torturing you
at the same time. But you know it's not in a mean spirited
way, it's in aplayful way. So this this whole thing...
and he would organize hot lamps so you stay warm and this
type of thing. So there's things like that when you are
always dirty and covered with blood..it's very uncomfortable
when they put this stuff on you. You know, you have a driy
shirt and someone has to cut a hole in it and pour blood on
it and it runs down yourarm and they put blood in your hair
In Mexico when we did TOTAL RECALL they always put this oil

on that was supposed to be sprayed out ofthe engine when
they put the drillinto this engine. so it's very uncomfortable
and you feel like you're doing this together with him. You
get this kind of buddy feeling and then you tease each other
and play tricks on each other and he has the same kind of
 in that way
mentality/,with the practical jokes and all this stuff as
I do so it makes it much more fun togo through that. It's
like you do something together. It's like you're doing
this movie with your buddy, together and that makes it much
 much more
more fun and then you go/all out if it gets to be difficult.
Like, the next movie coming up, TERMINATOR, putting those
appliances on for 3 or 4 hours each day. This becomes
very tedious. but he's very good, very funny during those
things, so that makes it fun. He'sjust very, very good.
He's been with me sincethe first TERMINATOR movie.

LL; And you just kept on going together.

AS: Well, there were two movies in the middle where he was
already on some other job, or something like that, so we
didn't work together, but in all the other films we've
worked together.

The end###

All Lance

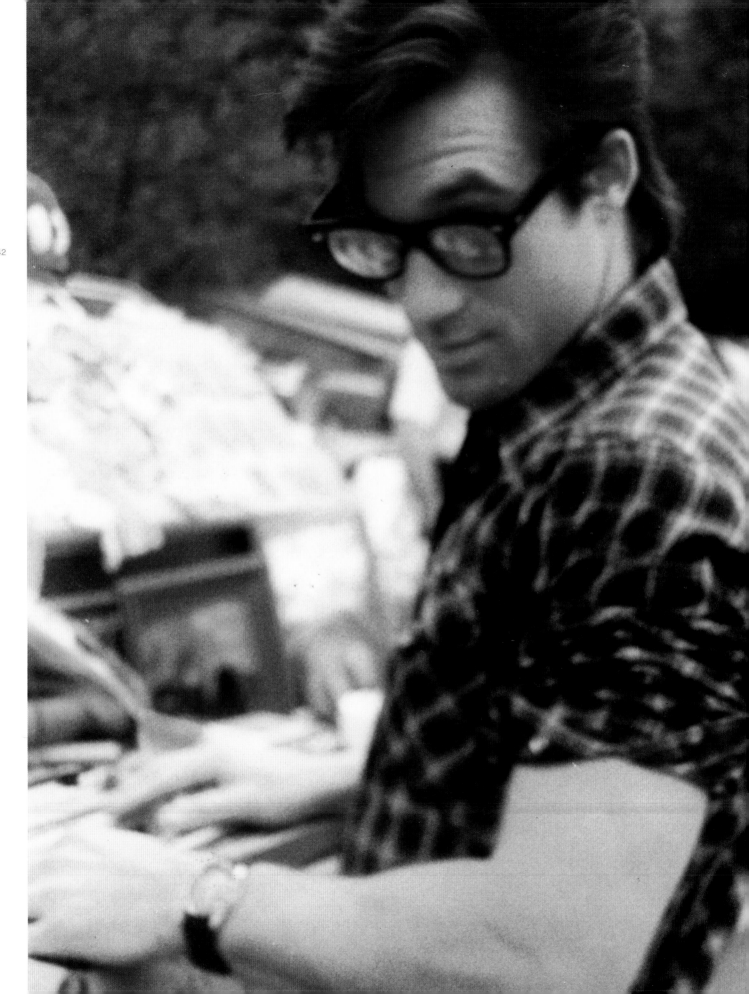

Lance on Deadline. Lance would have an assignment for writing an article. He would have an outline, do all of his research, get everything going, be about three-quarters of the way through and then he'd start to panic.

"I'm on deadline! I have to do some speed!"

So he would do some speed. Then, of course, he would write ten endings and he'd start shuffling them around. Any one of the ten endings would have been fine but he would get more and more frantic. The article would get later and later. I don't think you could ever think of Lance as a recreational drug user. He didn't get a little high. He got a lot high. Bobby Mayhem

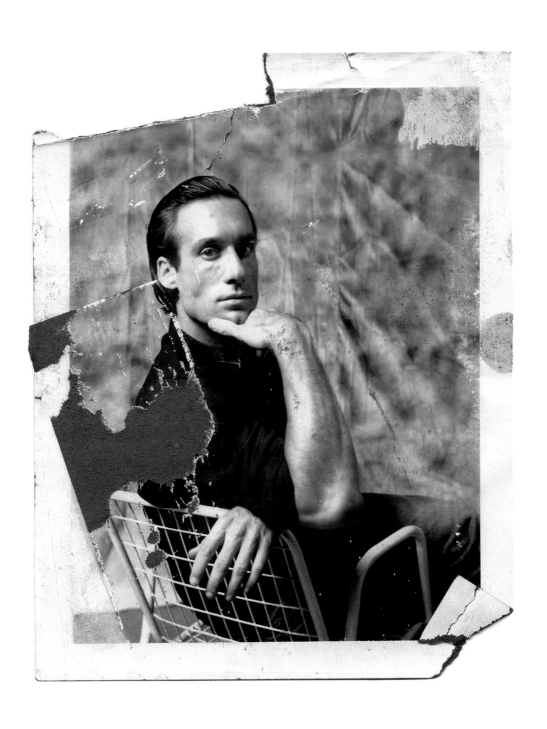

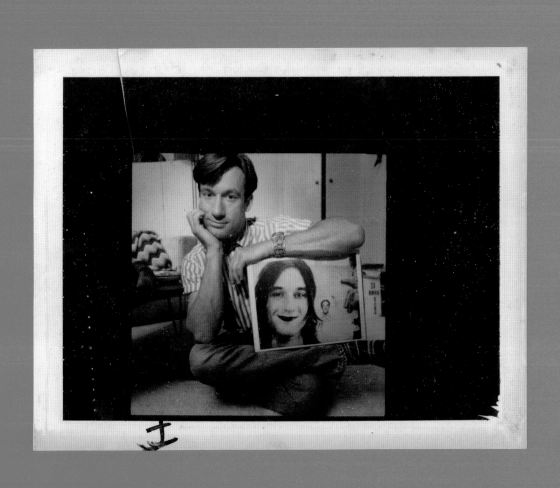

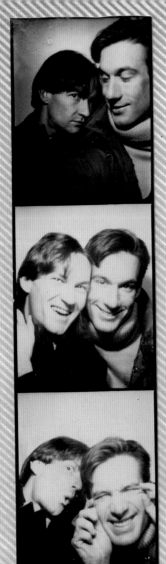

Taught by John Lennon:

$300,000 parrot sings unrecorded Beatle songs

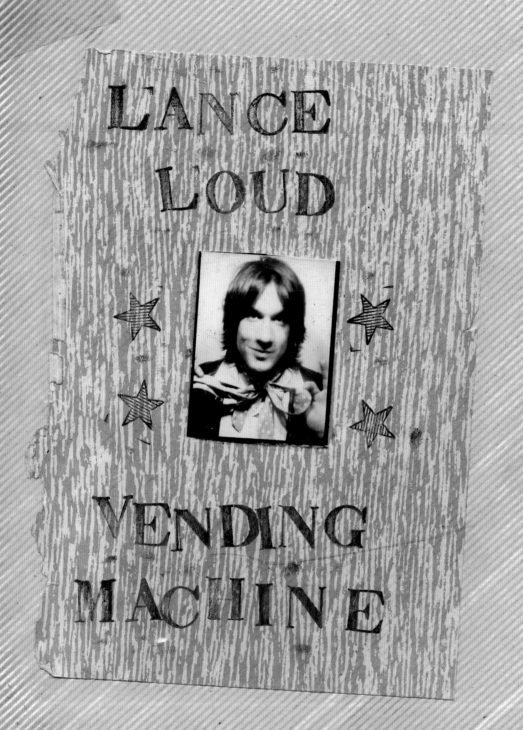

LANCE LOUD

VENDING MACHINE

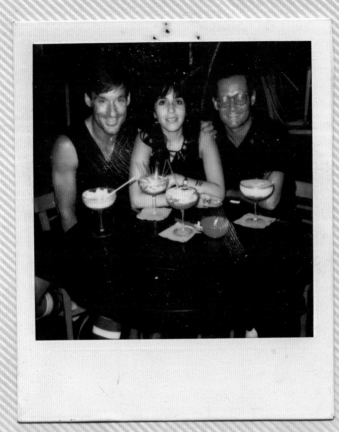

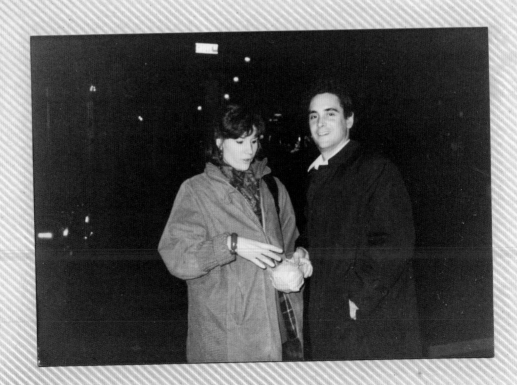

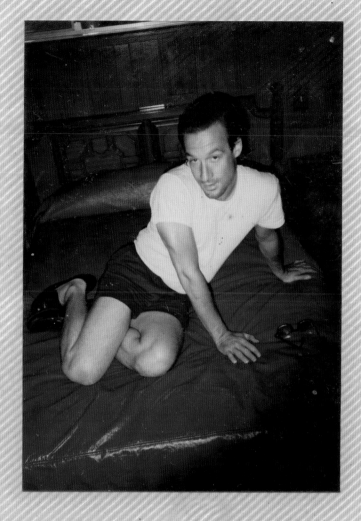

Frankly
40...

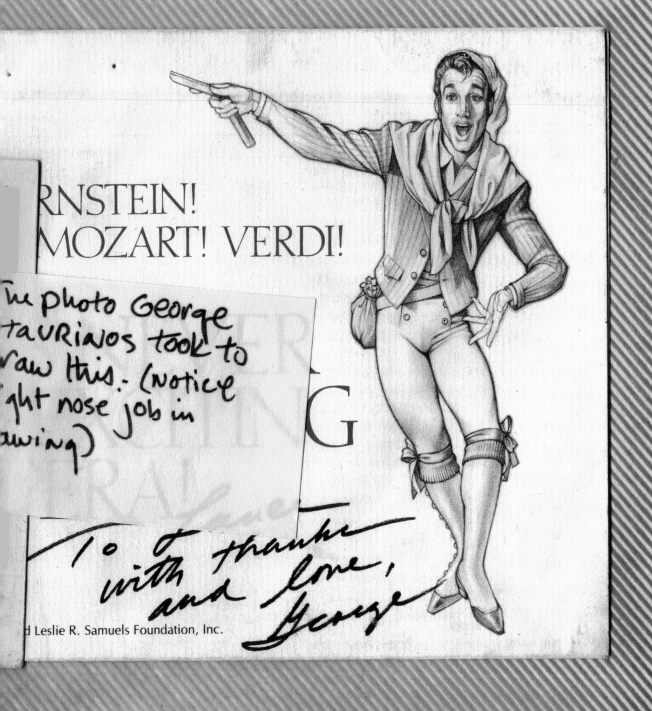

RNSTEIN!
MOZART! VERDI!

The photo George
taurinos took to
draw this. (notice
slight nose job in
drawing)

To ———
with thanks
and love,
George

d Leslie R. Samuels Foundation, Inc.

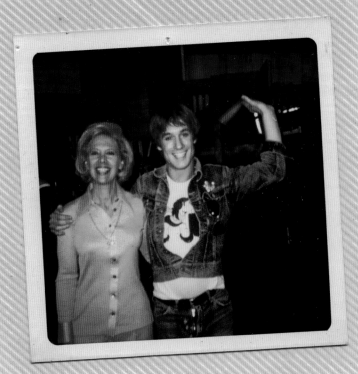

ME with Dinah Shore
and lotsa eyemake-up
and ~~hairdye~~ henna

So cute...
But a drag
in bed!!
1984

The Real
ME

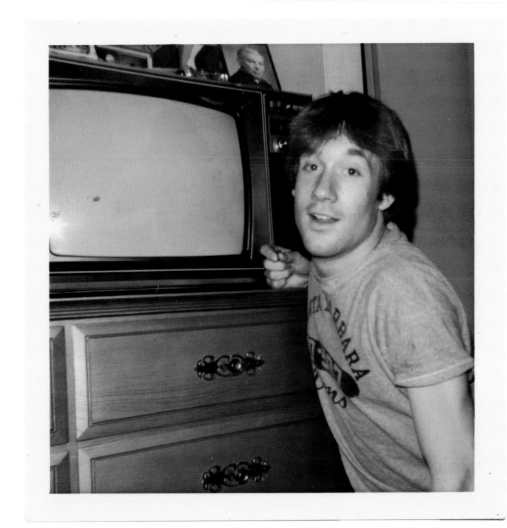

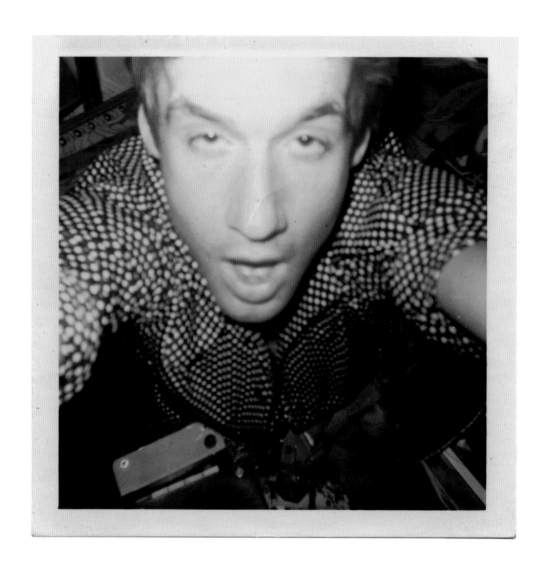

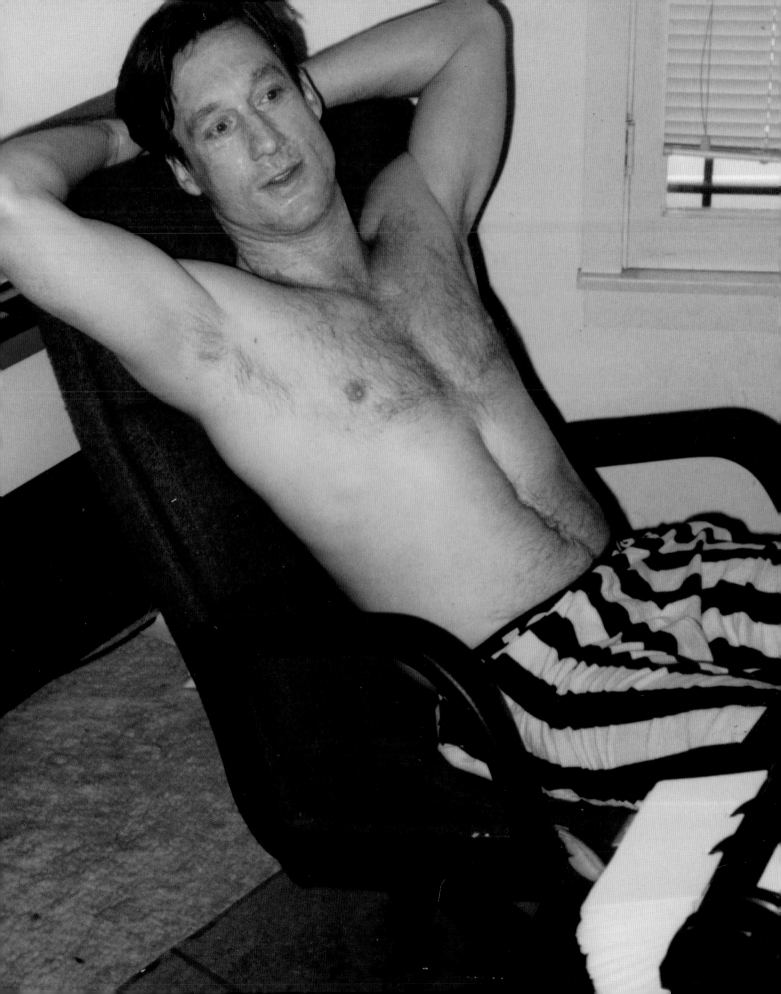

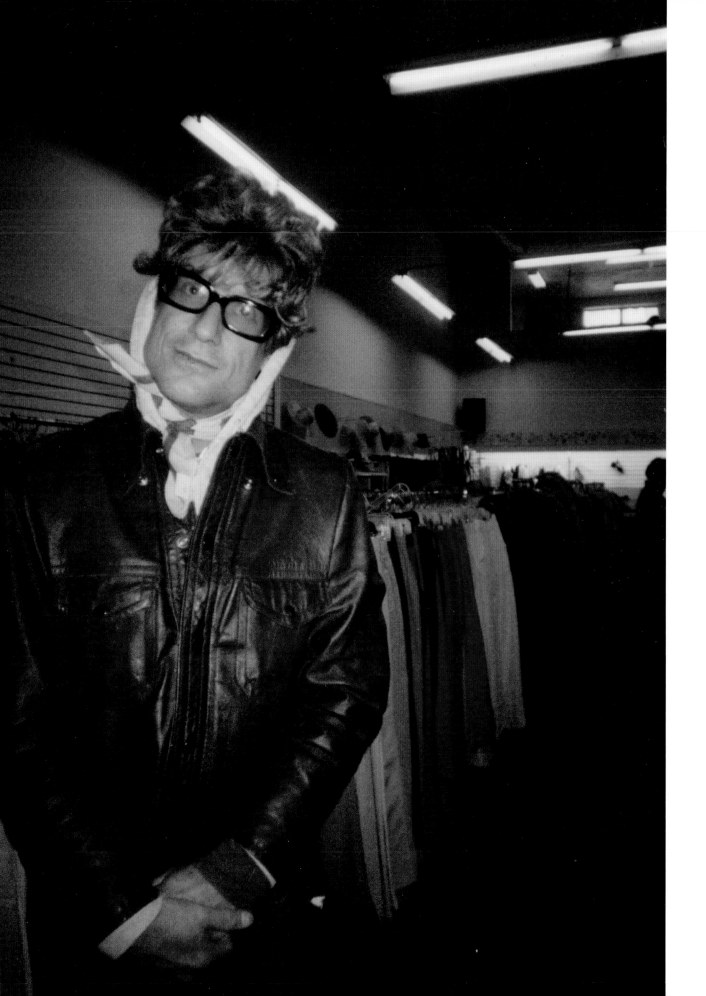

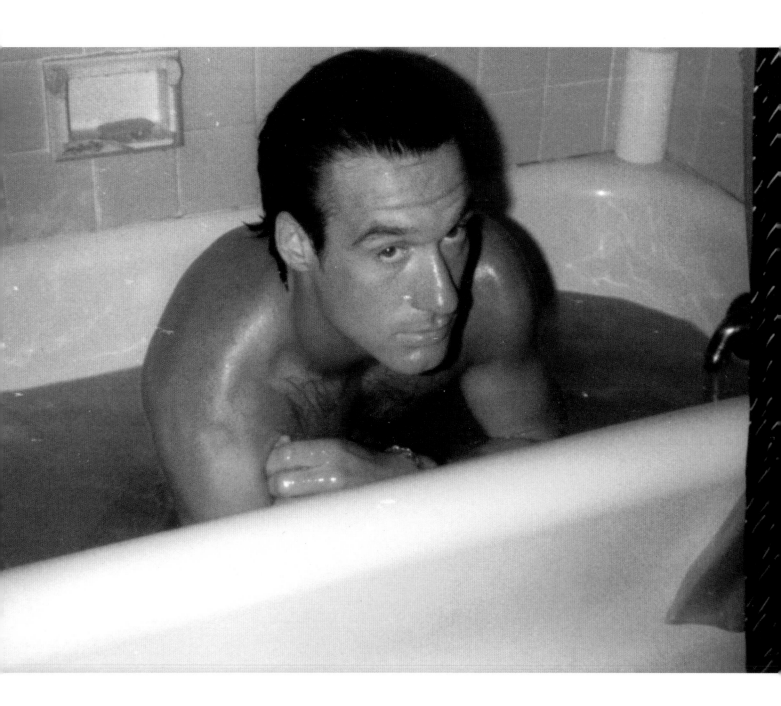

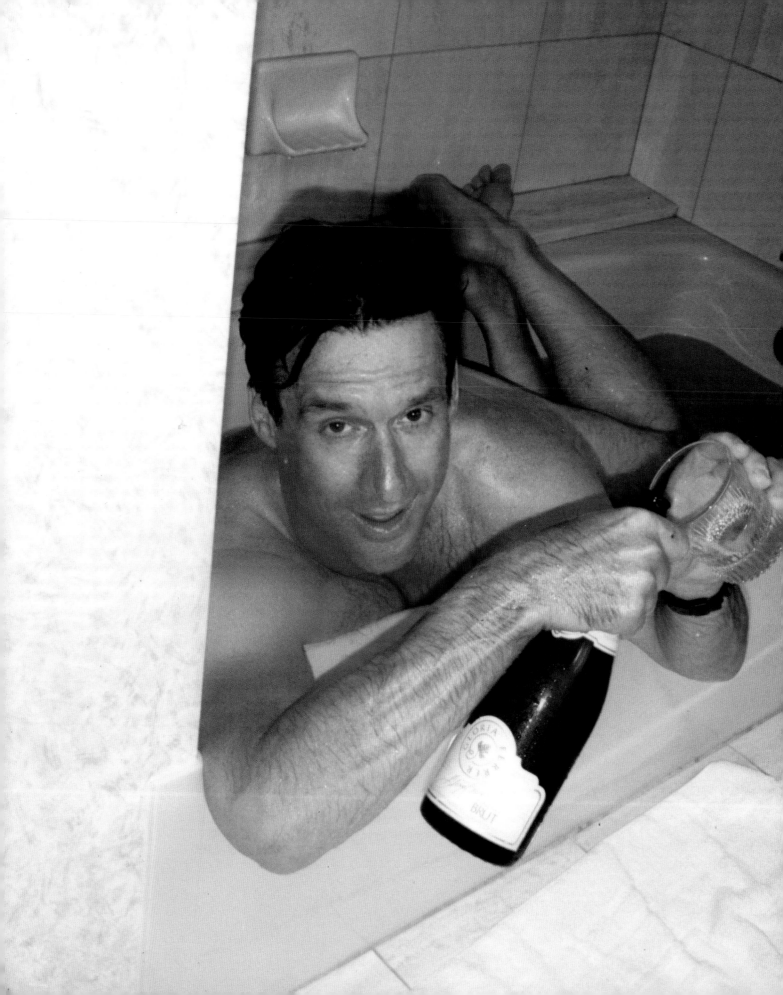

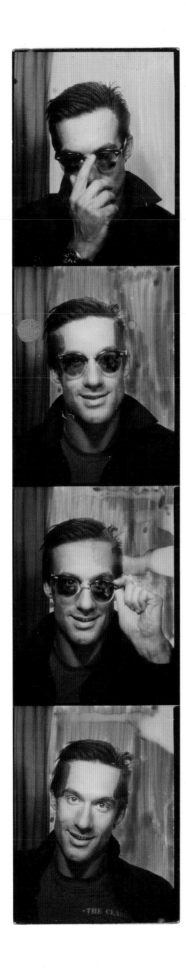

Wrap Your Flapper Around That! Wrap your flapper around that! This was one of my favorite Lance Loud culinary directives. Lance had a love for life but a stronger love for food and he wanted to sample it all and share it with everyone.

Lance and I had a weekly ritual of attending film screenings for our respective media jobs followed by dining excursions that were always fresh and unique. Long before the food truck phenomenon, Lance discovered the world's best tacos in what was then called a "roach coach" parked on Santa Monica Blvd. Lance's taste buds could vacillate easily between Roscoes' Chicken & Waffles to tuna tartar at Campanille. But when it came to baked goods and candy, everything was non-negotiable: it had to be elephant ears from the Blue Ribbon Bakery on Sunset and Gower, freshly fried dough from Bob's Coffee & Doughnuts at the Farmer's Market and chocolate-covered honeycombs from Littlejohns in the Farmer's Market.

Lance had his favorites, but none could surpass the gourmand goodness that his Mom would create with love and lots of butter. From shepherd's pies to Cornish game hens, Pat was a genius in the kitchen by never seeming to be in it. Pat Loud dinners were always capped off with homemade cakes or Lance's favorite, Pears Helene. Lance would scoop up a pear dripping in reduced chocolate sauce and signal the entire dinner table: Wrap your flapper around that! Rob Sheiffele

Lance (with Grant Loud in the background),
Christmas, 1975 in Pat Loud's
New York City apartment

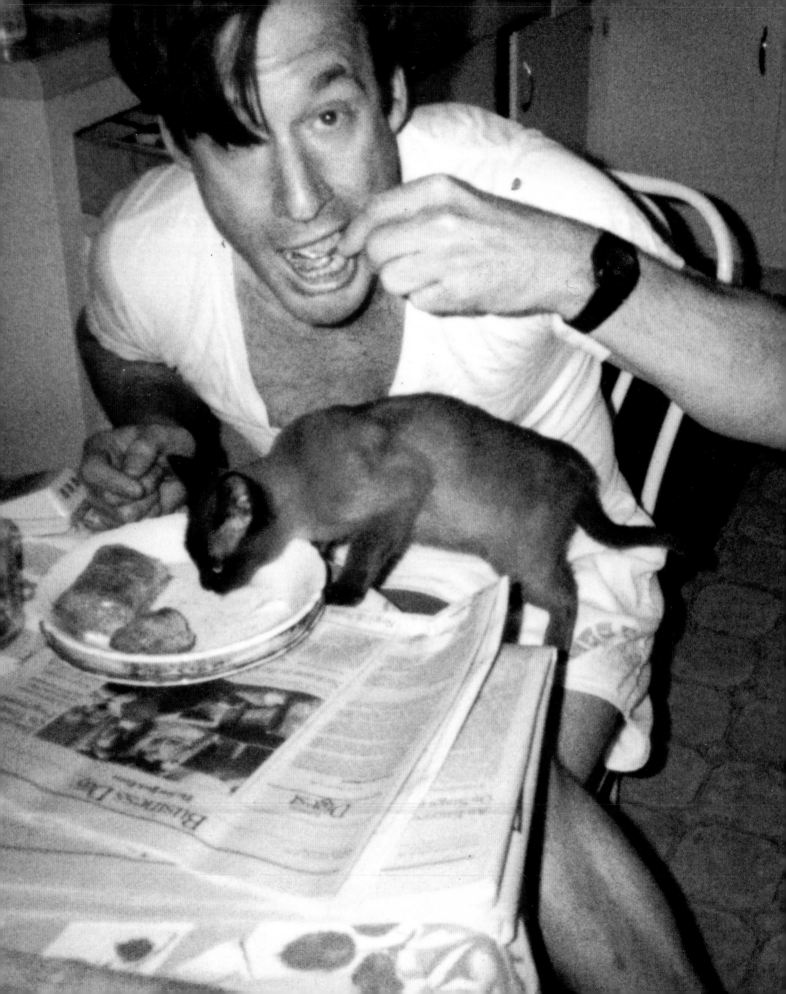

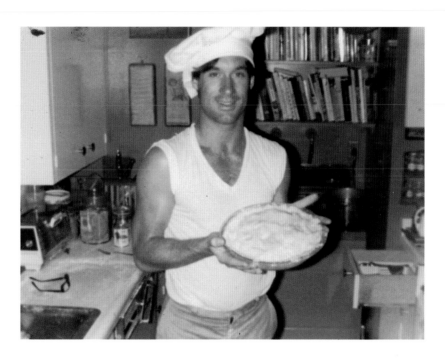

Desirable Freedoms. Lance lying at the end of my bed watching movies on VHS before they came to the big screen, laughing, crying and commenting throughout the entire film. Discussing the precious potential of cinema and its provoking fragments of desirable freedoms from the ordinary expressions of real life. It was just one moment in my friendship with Lance that will always make my heart smile. Christian Capobianco

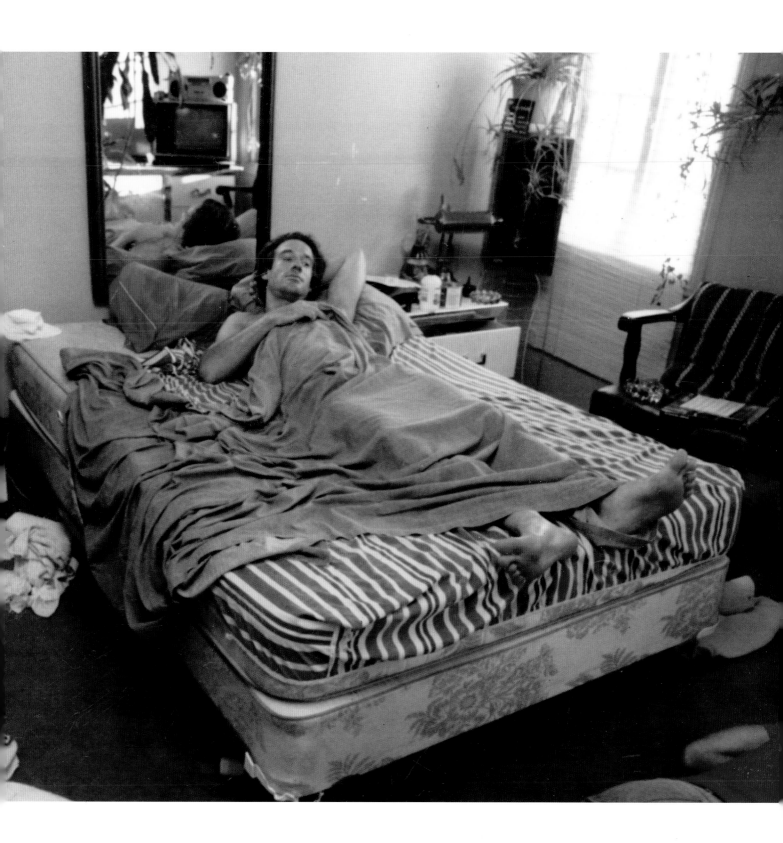

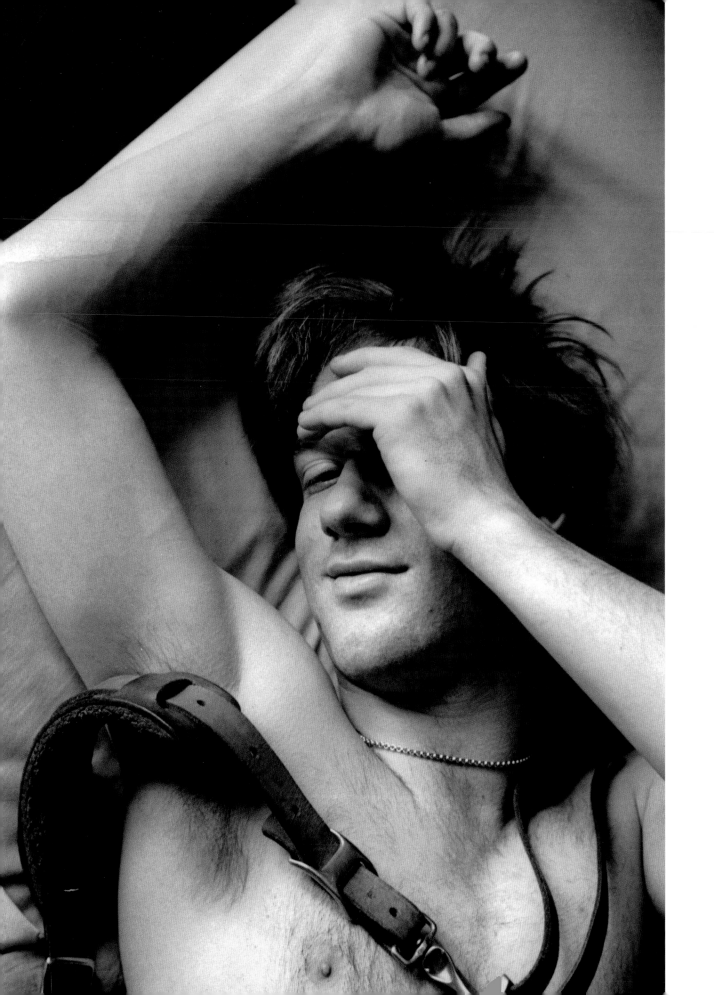

The Duke of Windsor left his throne for his duchess, Wallis Simpson, and the couple up residence in Government House in the Bahamas. / David Scherman 1941

Cover: April 24, 1939, Neville Chamberlain / Wide World Photos

City Slickers 7:30 Pathé

~~Available Before Depart~~

11:00 PM Leave for NYC
Jeremy La Guardia 9.00

Jean Paul Goode Wed. night. 9:00
Simone – 818 9535224

Gino
Mike Glass –
Shanta 6522565
Don
Andrew Roth 8565650 Am/Film

Wolf (Oct. 11)
Debbie
Debbie Trent 2042094 Sandy Bagg
Doug 28008210

Doug
Donnie

Doug
Michael Martinson 4698198

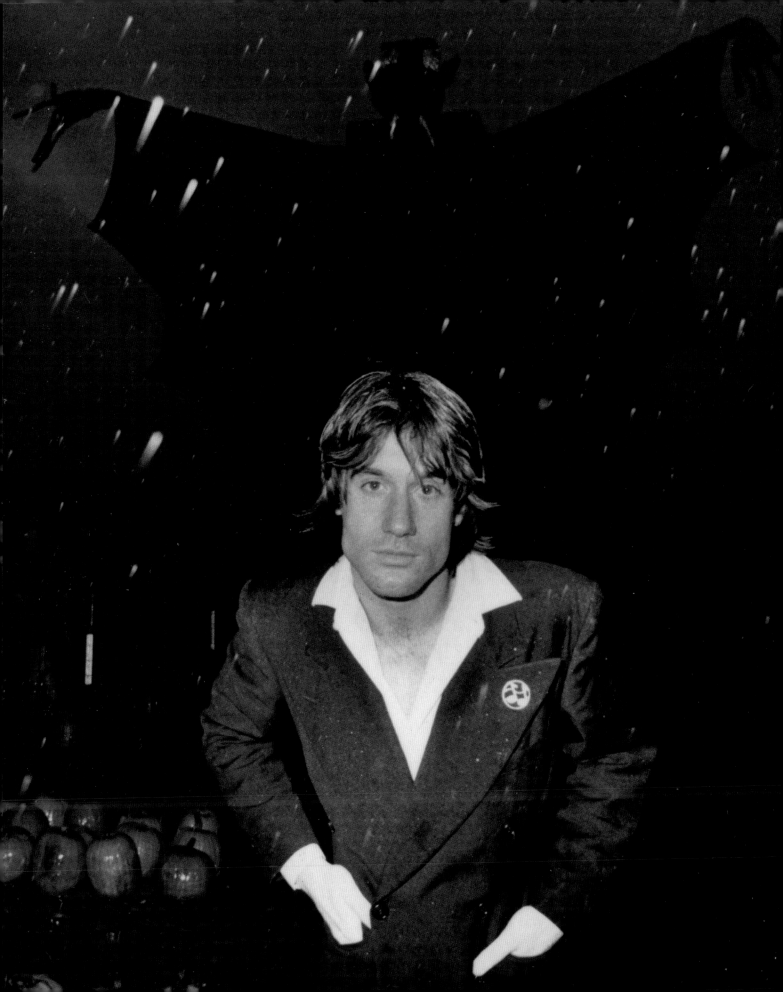

Lance, Halloween, 1975 on Long Island
in a pumpkin patch, photographed by
Christopher Makos

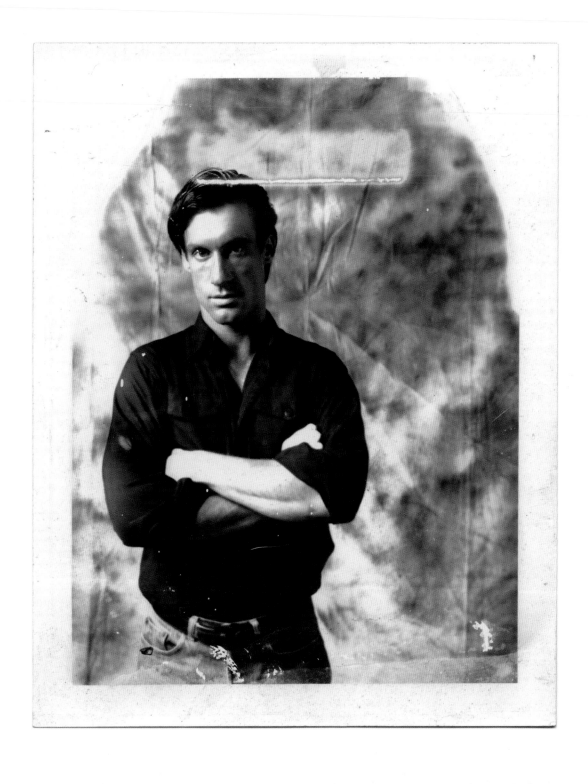

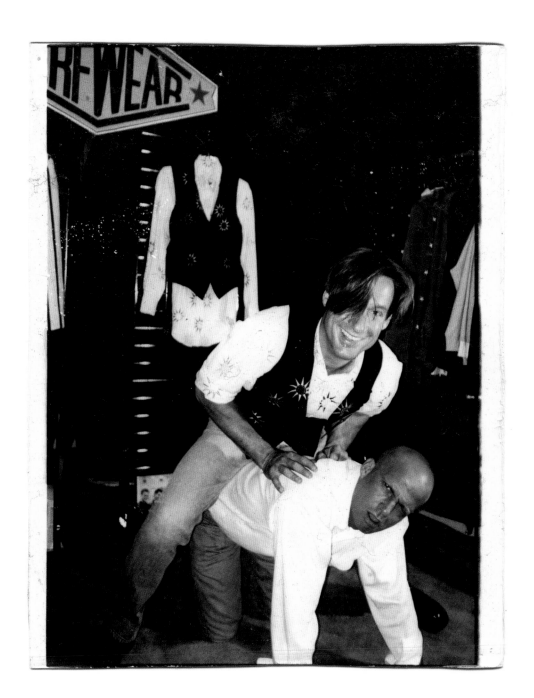

Lance with Gregory Poe

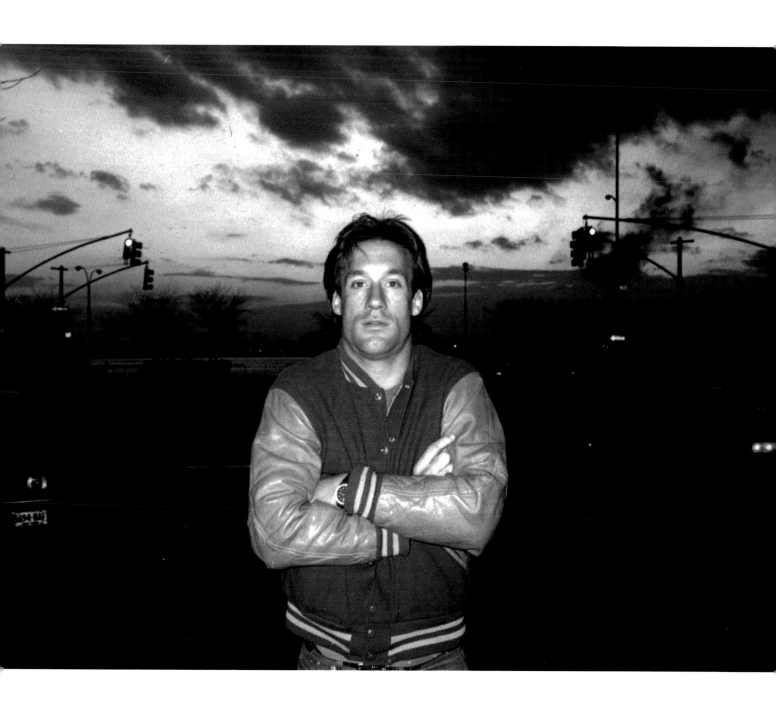

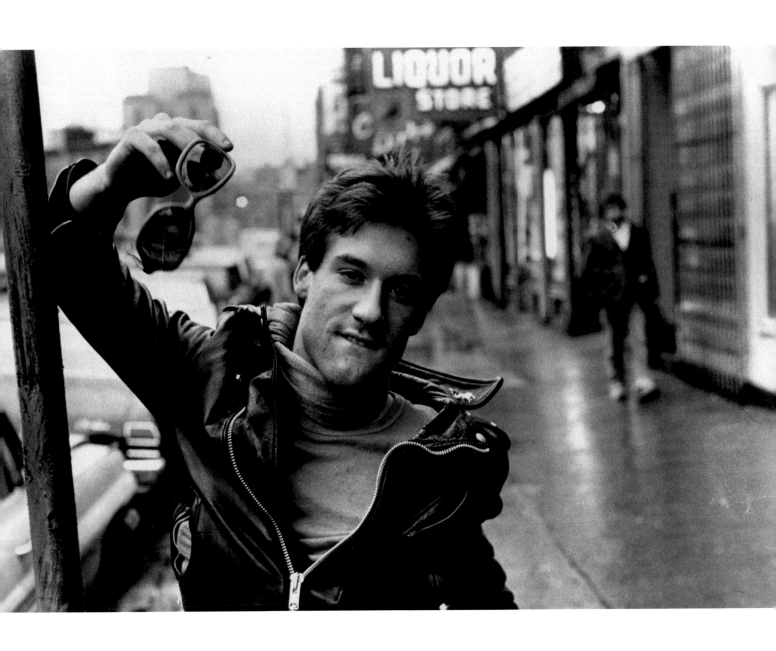

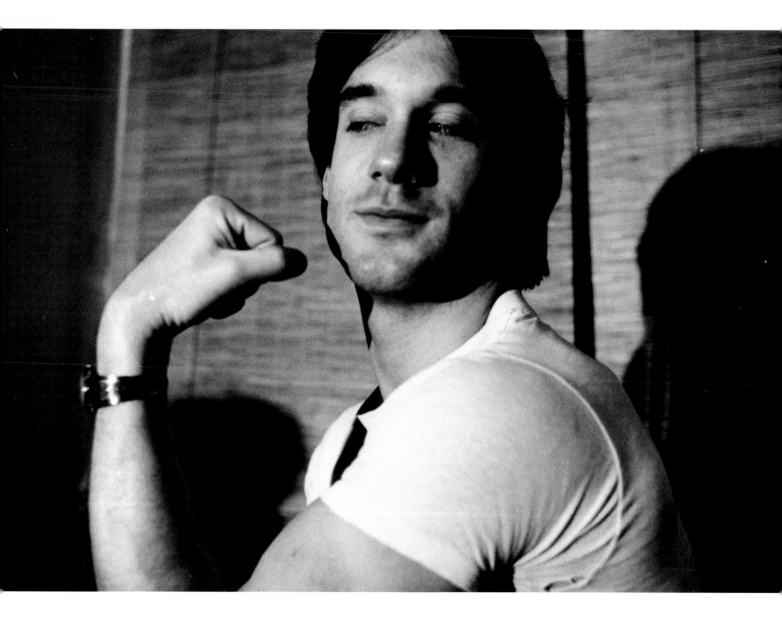

Photograph by Lisa Jane Persky

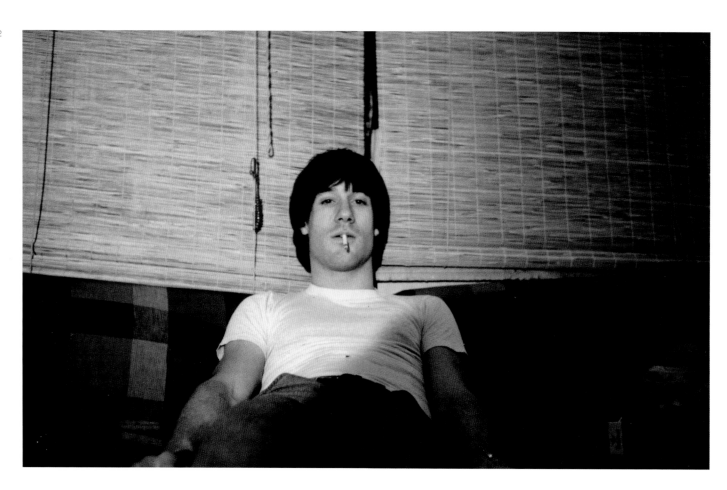

Photographs above and right
by Lisa Jane Persky

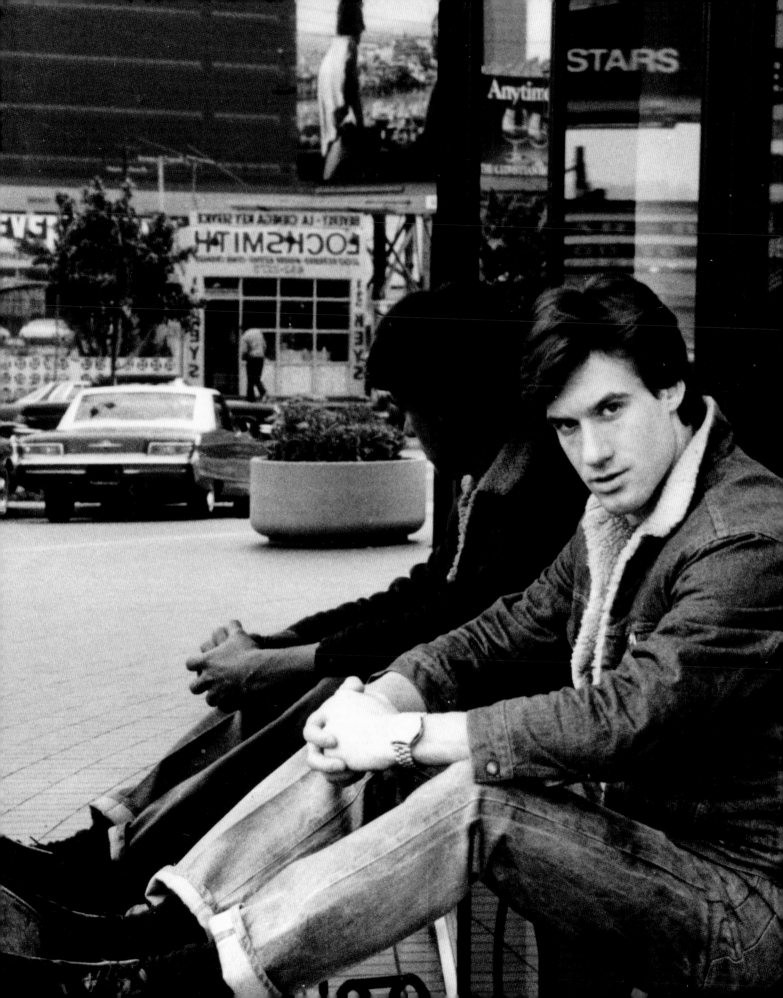

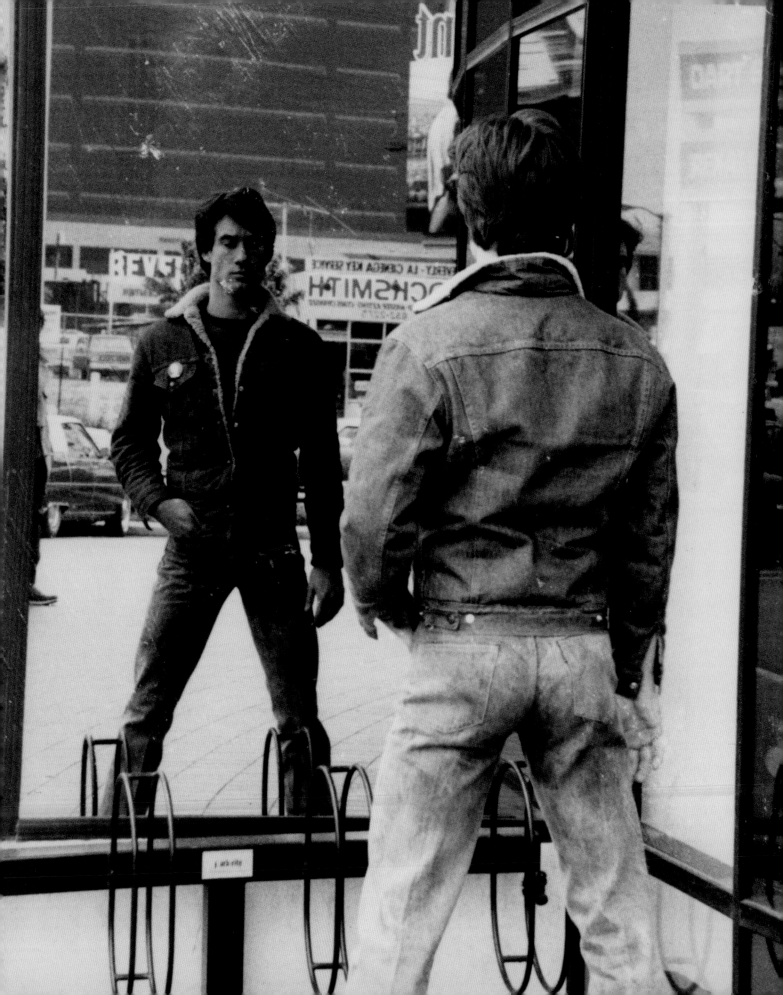

DEAR jeune homme,

C'est moi, Lance Loud and I still remember you calling and your voice edged with red satin being so sweet on the telephone to someone you couldn't even remember. Of course, you got over **THAT** one pretty fast and I was left semi-waiting but prepared for the non-response. I got. ANYWAY, that doesn't matter to me now, Jesus, you may be uglier than me... But WAIT... what **does** interest me is that you know what I look like, you've witnessed my impetuosity scrawled on the back of some smudged photos. You have seen a smidge of **LANCE LOUD**, its like having a vague relationship without having to bend to the others personal set of rules, regs. and whatnot. I always think when I go out now, that perhaps I'll pass you on the street — totally natural, not putting on any show for anyone — or at least not putting on a show aimed at you, and you know me and; well, I can't explain it down to the nub; so lets say its "reassuring".

This infatuation with you playing MR. X won't go on to any great extent, someday I'll be appeased in some other way. Perhaps I'll stop ~~~~ about anything at all and join the groovy gang down at the Limelight. Don't be too involved this ain't no 'Strangers on A TRAIN, a note stuffed behind your bell is all you'll get from me — its like **BOO** Radley in "TO KILL A MOCKINGBIRD" if you're acquainted with that fab piece of lit. This all is **terrifically** verbose for me but I'm in my writing class at NEW School now and this helps me ignore the fact that I haven't finished a paper for it since I asked you for a Typewriter — Anyway (my favorite word)), sometime I'll wait for you to come out and you won't be ½ of what I want my private public to be like so I'll stop (if I don't stop way before that) and wait for someone else I don't know to call. By the way, I cut my hair off and its still Radically red. LANCE LOUD

Family

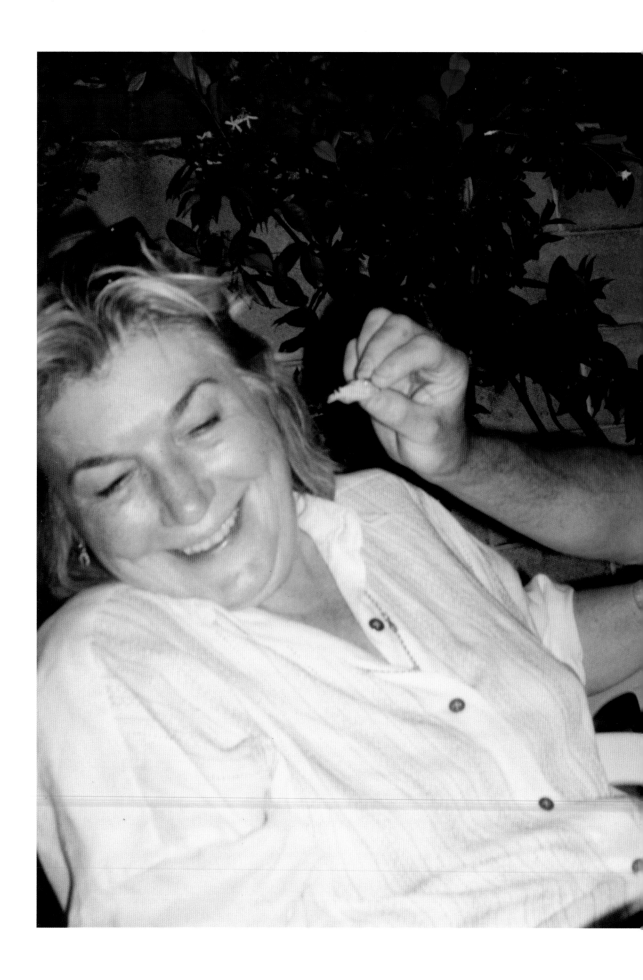

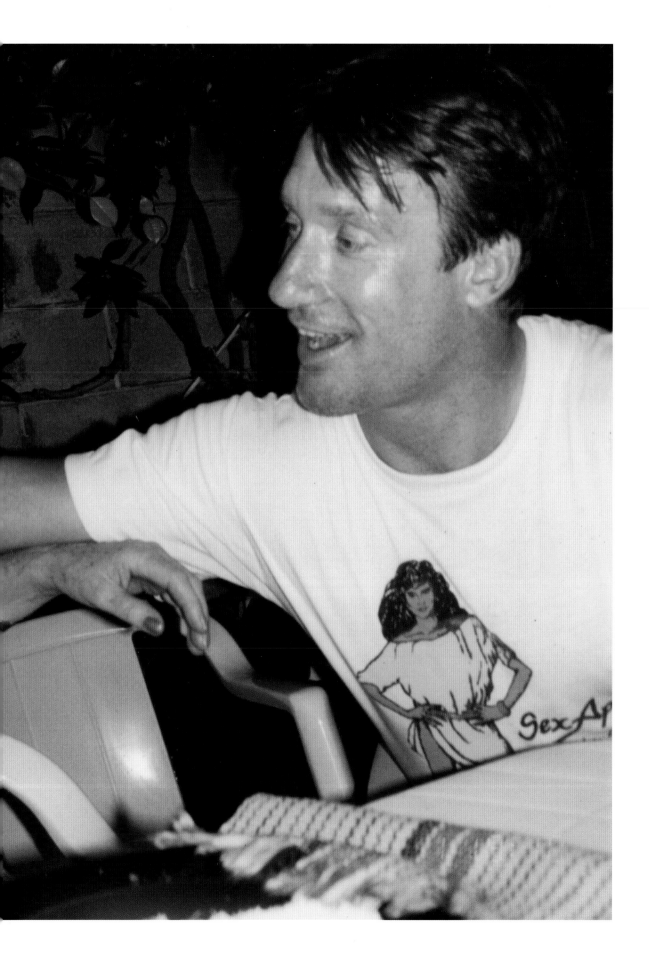

Pat Loud with
Lance in 1990

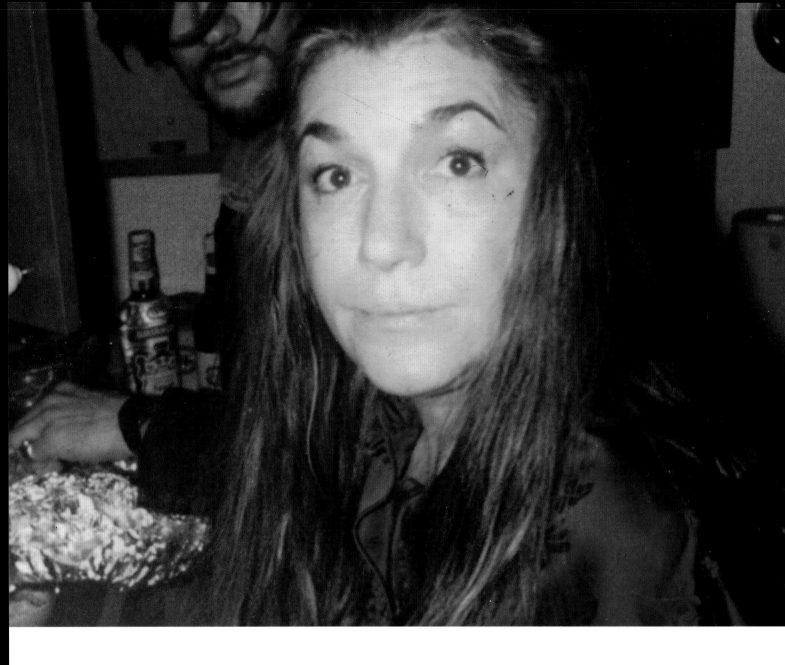

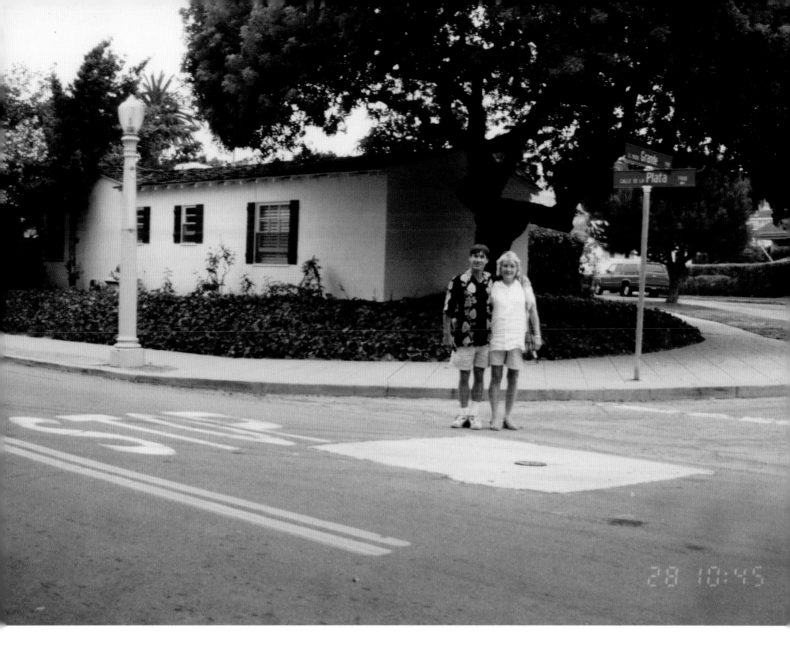

Pat Loud with Lance in 1995 in front of the house
where Lance was born in 1951, on June 26

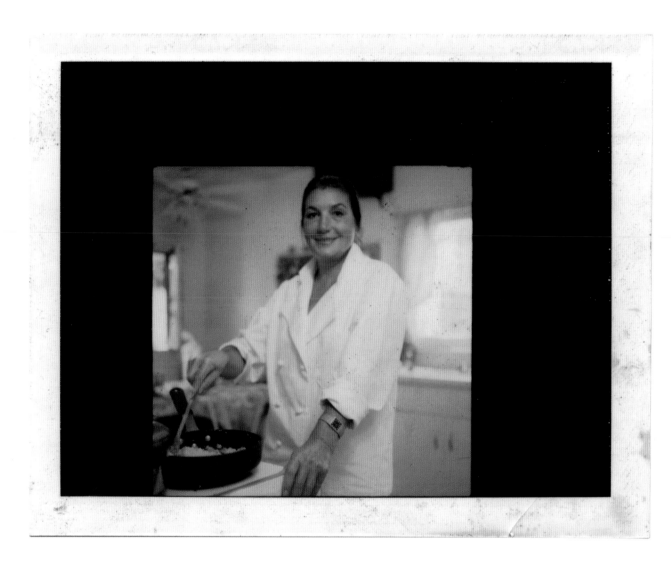

Pat Loud cooking dinner in her
Los Angeles home

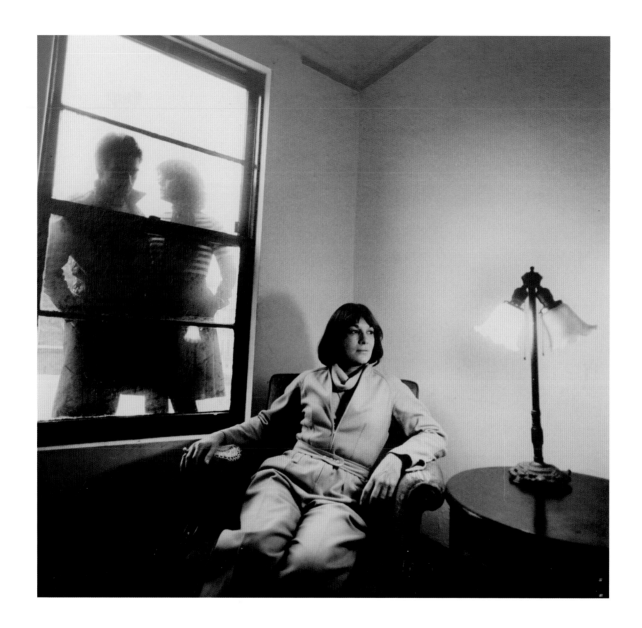

Portrait of Lance, Delilah and
Pat Loud by Arthur Tress

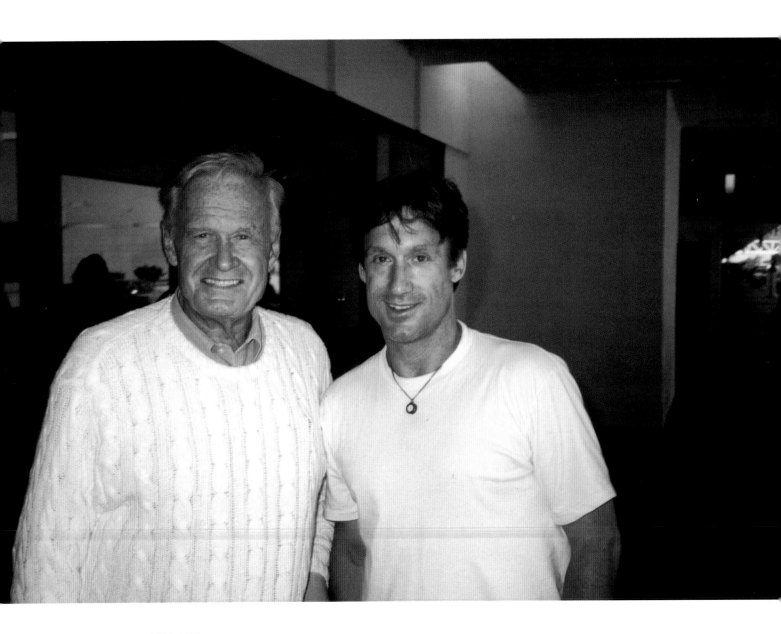

Bil Loud with Lance at LAX in 1998

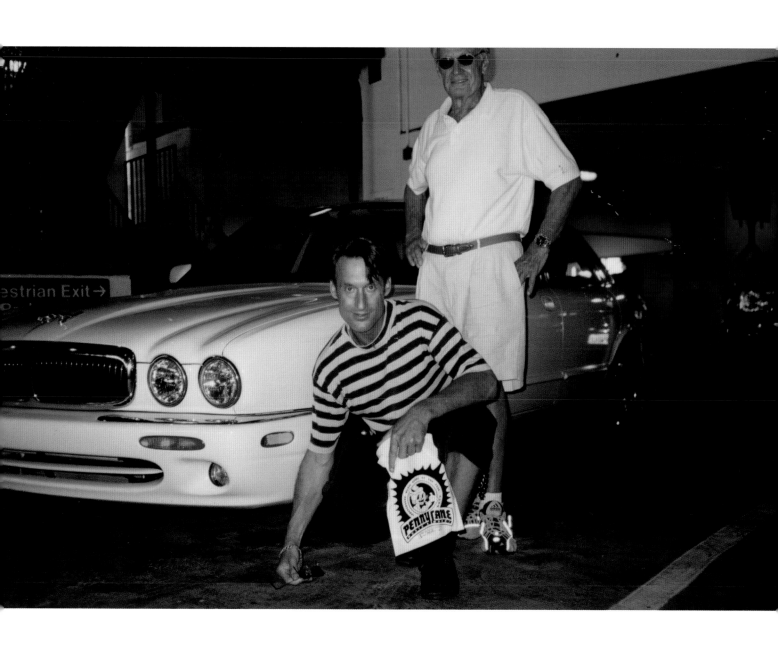

Michele Loud and her high
school friend with Lance

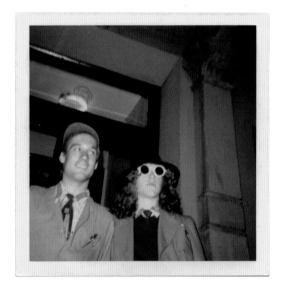

Lance with Kristian Hoffman

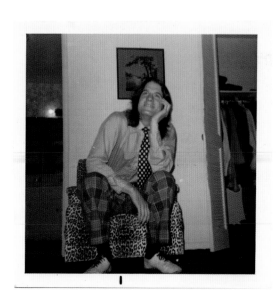

Grant Loud

Dearest Lance, Love Dad. Thank you for your wonderful letter. I thoroughly enjoyed it. The contents were well constructed and I very much enjoyed your analogy of the return of Lance vs. the fall of the father. It is also reassuring that you were concerned to an extent with the marital problems of your problem-plagued parents. It is even more rewarding however, to know that at times in our relationship you did feel close to me and did consider me a father-friend and not always a horrible money-dispensing crocodile.

You say you are going to enter the corporate grind so that you will be accomplished and successful. Well, Lance, really, that isn't too important to me. I think you should take some further formal training to prepare to support yourself. But whether you come to visit me as a famous movie star or as a broken-down insurance salesman, it won't make an ounce of difference what you've accomplished, because I'll know you tried every day to the fullest measure and that you brought happiness and cheer to everyone that you met; that you went through life with that charming, gay, fascinating personality and with style. And so when you come see me during our future life, come see me as a very good old friend, who just wants to enjoy you and who you want to enjoy and that, my boy, is a real life father-son relationship.

But back to the marital split subject. I really have no desire to return home. Loneliness is not one of my problems. And I truly want to see if I can forge the new life for myself that I have considered for some time. For the past few years, I think Patty and I more-or-less targeted the summer of 1972 as a time for the split, the time when the boys graduated from high school. So you might say the termination came a little early. Many people say that its silly to continue a marriage because of the children, but I honestly believe that the whole family should remain together until the children are capable of taking care of themselves.

Your mother is the most difficult to forsake, she is truly the only person I ever really loved with my entire heart and soul. She is a completely honest woman. Her honesty makes her very beautiful to me. She's been my Rock of Gibraltar, both as a snug harbor of security and also as a perilous navigation hazard for 20 years. I adore the ground she walks on and I love living with her but at the same time, marriage requires 100 percent attention and devotion to duty, a living style of "all or nothing at all." We must be together in all things. I can't understand how we American people can get ourselves into this togetherness practice. Actually, I think it's a ridiculous situation that the family is breaking up. I really think it's probably that Patty and I have annoyingly been working on it for about five years. Anyway, right now maybe it's like the lemmings walking to sea. How can we explain everything we do? Why did I have five fine children? Why did we move to Santa Barbara? Just how much control do we have over our destiny? It's just too tough to keep fighting to get everything together and try to keep everyone happy and calm. So that's the way it is. Take care of yourself and don't take any wooden nickels. Bill Loud

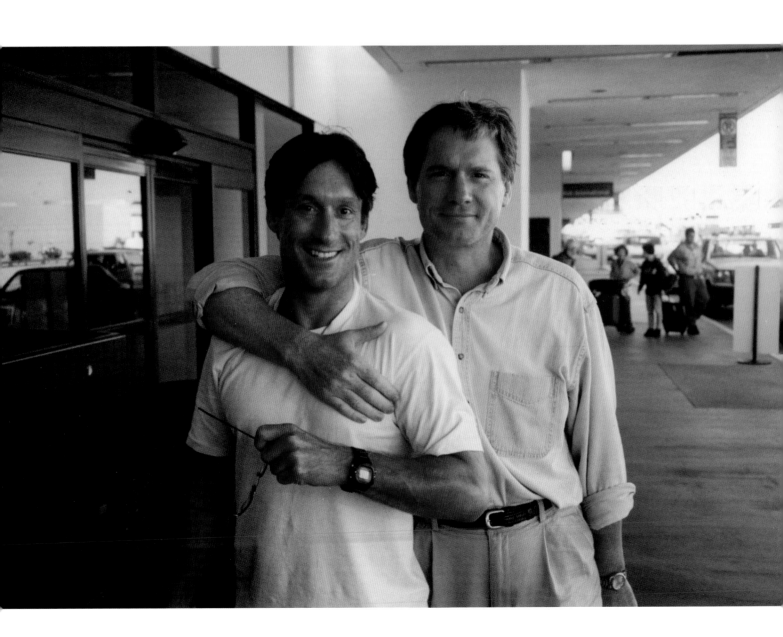

Lance with Grant Loud

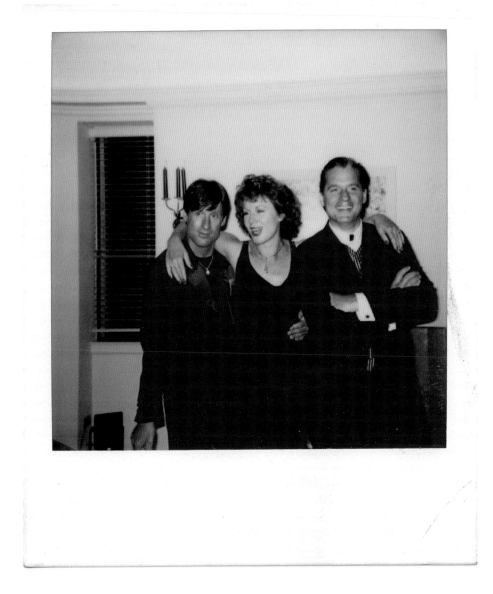

Lance with Delilah and Grant Loud

Walking at Night. I had trouble sleeping as a young person. Life had begun to move very quickly since we'd relocated to California and I spent long nights struggling to process all the changes. I'd lie very quietly in bed, as though by feigning sleep it might trick my body into feeling rested in the morning, the noisy monologue in my head careering out of control.

It was Lance who showed me a way to get through it.

I was maybe 12 or 13 years old when his tap came at my window, but I'd heard them long before that. Stifled laughter and excited whispers, Lance and his friends, out in the night. Their voices skipping across the dry, hot September winds that pushed the oaks and tall grasses up and down the foothills of Santa Barbara.

"Grant! Wake up!"

"What are you guys doing?"

"Oh God!" Lance. Exasperated already. "Come on!"

 I couldn't believe it. It was like being called up to the majors. You're in, kid. Don't screw up. I was dressed and through the window quicker than Alice after the rabbit.

There were five or six of them. Mostly faces I didn't recognize, two or three years older than I. The group scrambled up the steps behind the house and around the corral that Kevin and I had helped Dad build for Michele's horse, Charlie.

"Shhhh!" Lance. The taskmaster. Then, in a rushing stage whisper he made the introductions…

"This is my brother Grant. He's really cool so don't give him a hard time. This is Karen. She always dresses all in black. You know that cool house on Tremonto that looks like a castle? That's hers. She has, I am not kidding, the most unbelievable record collection. Of course, only original English imports."

To Karen, snide; "Somebody's rich!" Then, continuing, "This is Guy…say hi to my brother, Guy." Silence. "That's a joke. Guy never talks to anybody, but then, he shouldn't have to because he's maybe the best artist alive today. Don't get a big head, Guy, I didn't just say that. His parents want to send him to military school to straighten him out, but Granny loves him and Granny's clutching the purse strings so…" And so on. It's all a blur really. It was at the time as well.

Except the night. I'll never forget it. Electric, magnificent. Stars like big, fat shards of glass cutting their way out of the sky. The hillside bathed in moonlight and silence. Us, a band of misfits, scuttling down the street. The rest of the world safe in bed.

And the stillness. It covered everything, like a blanket. It startled me. I suddenly noticed that my usual inner-dialogue—the deafening, back and forth of escalating worst-case scenarios—had gone quiet. There was only peace, camaraderie, and our shared forbidden activity. It was a powerful mix.

We walked along in a place out of time, our group a movable yet impenetrable asylum. There was no wicked behavior. It was enough for us just to be out in the night, picking up rocks that glowed in the moonlight, jumping into the ditch to avoid the occasional passing car. The group always surging, mixing, reforming. They talked about teachers I didn't know and movies I couldn't get into yet, so I mostly just listened.

I was walking next to Lance again when I noticed that we were near the Rivera Theater, easily a couple of miles from our house. The spell of the night was wearing off and I was starting to get cold, but he was as enthusiastic as ever. Teasing, asking questions, making comments. Never exactly in the lead of the group, but always generating the heat to keep it powered.

I yawned.

"What's that on your tongue?" Lance asked.

"What?"

"That thing on your tongue. Here, open your mouth."

I did. His finger darted in and wiped something bitter on my tongue. I spat it out.

"Don't! Oh, you stupid oaf!"

"What was that?" I asked, spitting again.

Guy said, "About five dollars," and laughed.

"Never mind." Lance sighed. Disappointed.

Then the magic was gone. I don't remember the walk back.

And that was Lance to me. There was nothing malicious in him, but he was never a harmless companion. He had a knack for being able to present you with an infinite variety of choices, where you had previously only considered one. To him, these choices were neither good nor bad, dangerous or safe, they were all merely doors to be opened. The ones you opened defined you. Even more so; the ones you left closed, unexplored.

His company was not a wise choice for the uninitiated, the unsure, or the easily swayed. He was elemental, volatile. Full strength and straight from the bottle. No childproof caps or warning labels. We all grew up fast around Lance. Mom and Dad too. Bewildered, charmed, disdained, adored, destroyed, encouraged.

I wasn't invited to join his group again, but walking at night continued to be a source of solace to me then and throughout my life, and it's only one of the many things I'm indebted to him for. It's something I never would have had the imagination or courage to do on my own. To Lance, it was merely another door to open. Grant Loud

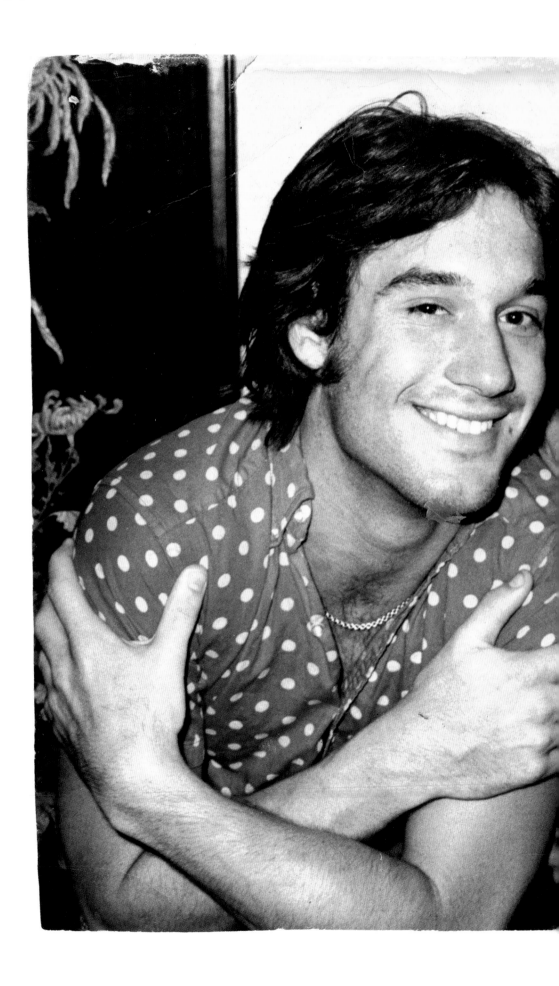

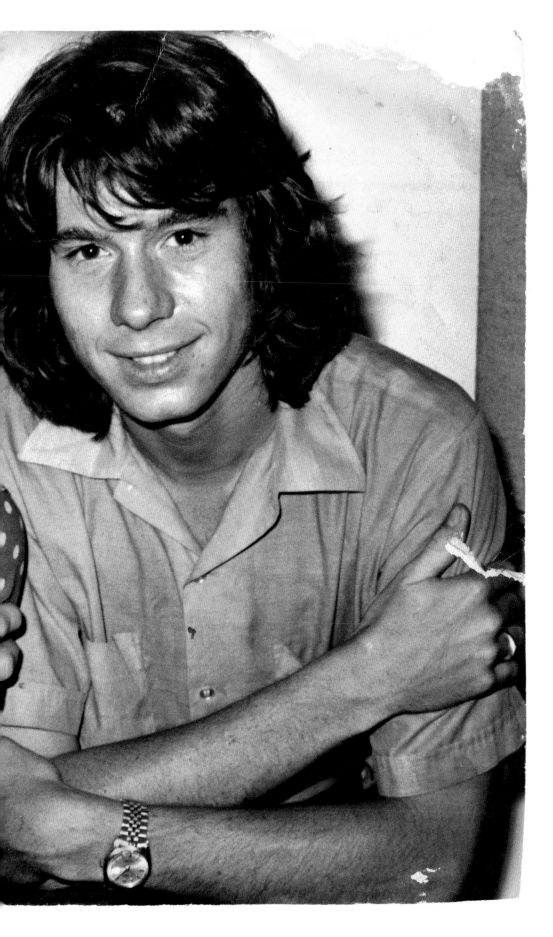

Lance with Kevin Loud

Exacting Pure Justice. Lance Loud had many remarkable attributes. The one I most admired was his intolerance of vanity and his willingness to address it with his god-given mystical ability to exact pure justice. There are countless stories of his exploits, which I came to call "The Ride of the Grim Reaper," but the one I most enjoyed occurred during a New York City business trip I took in the early '80s.

I flew there from Houston to interview insurance brokers for the marine business I worked for, which ran about a million dollars a year in gross premiums. I interviewed a couple of brokers in the morning then met with one in Manhattan's high rent district that afternoon. The firm's CEO was all that, with a traditional corner office and credenza loaded with personal pictures with Presidents and celebrities. Of course, no such successful office would be complete without the perfunctory trophies of past success in the form of Ivy League degrees conspicuously posted about the room. After waiting the appropriate amount of time in the lobby, I was shown into his office and there regaled with stories of wealth and riches and an endless passage of famous names.

Unfortunately, we never got down to the cost of their esteemed services by the end of our appointment and I had to leave because I had dinner plans with Lance.

The CEO was persistent. He insisted our appointment included dinner and that he had made reservations for us and his guys at the city's best lobster house after finding out that was my favorite food. I had been ready to end the meeting with him halfway through but since I did respect his tenacity, I let him invite Lance to dinner with us. The big surprise was Lance accepted. Having dinner with a bunch of insurance guys did not seem like Lance's "thing," but he did have a wide-ranging curiosity for life and the strength to embrace it.

So there we all sat in this fine restaurant: four Brooks Bothers suits, though I believe the CEO was wearing Brioni, while Lance wore a stunning Red jacket, black pants, a T-Shirt and boots. After regaling us with his insurance accomplishments, the CEO's conversation became demeaning when he expressed his disbelief that Lance played with a punk band in such seedy places as CBGB's.

In uncharacteristic form, Lance said nothing after the CEO bragged about reading *The New York Times* and *Wall Street Journal* from cover to cover in less than 15 minutes every morning. He even sat quietly as the CEO described how beautiful the city's skyline is from the back seat of a Rolls Royce driving along the FDR Parkway.

Then the first course arrived at the table: salads. Everyone had one except Lance. His place setting was bare. The CEO took this as an opportunity to lecture Lance on the benefits of balanced nutrition. He told Lance that a person cannot live on meat and potatoes alone and that people need some roughage in their system to keep it all moving.

Again, Lance sat quietly without saying a word in defense. I was starting to become alarmed by his passivity and was letting the CEO know in no uncertain terms to back off when the Grim Reaper struck. Lance never did need protection. Without uttering a defiant word, Lance lanced the inflated ego of the CEO with surgical skill.

The largest doggy bag I have ever seen was place down in front of Lance at the table by our waiter. It contained lobsters, steaks, side dishes and even a bottle or two of wine. The CEO was dumbstruck. Lance politely rose from the table, thanked the CEO for dinner but informed him that he would rather dine with honest people and quietly left.

After that the CEO collapsed into a defensive blob, raving with hollow affronts. Here was a guy that had lived a duplicitous life and in one penetrating blow, Lance exposed him and his fake life to the world. I have never seen someone cut so deeply to the core before or since that time. After that the conversation returned to insurance, but now instead of proclaiming what their firm could do for my firm, the conversation centered mostly on what they could do for me personally.

We never did business together and since that evening I have never spoken to the CEO again. Lance knew where falsehood lived and how to confront it. Kevin Loud

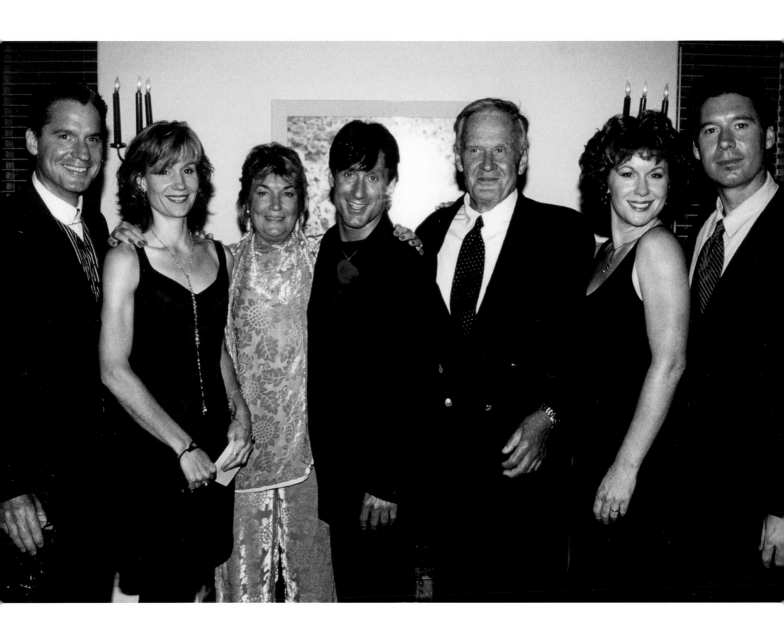

Grant, Michele, Pat, Lance, Bill, Delilah, Kevin Loud

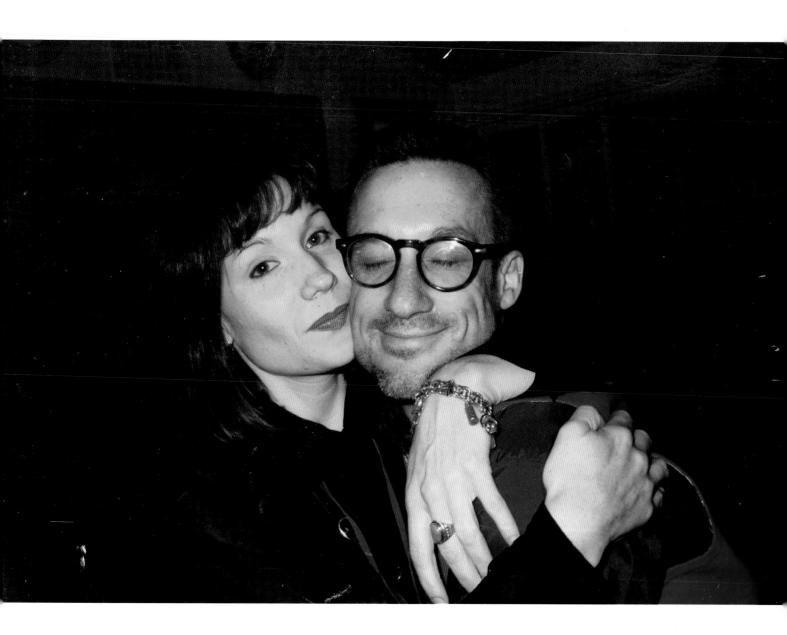

Michele Loud with Lance

History

Looking After Lance. Though Lance was the oldest of us children, from a very early age I realized he was the one who needed the most looking after. I can't remember when this knowledge arrived on my doorstep but I feel like it was always there. If there was trouble anywhere, Lance was usually in the middle of it and I felt it was my duty to try to extricate him.

This lasted all the way through adulthood. Lance and I took apartments next to each other and even after I was married, my husband and I lived close to Lance. I think I understood his vulnerability better than most people.

So, when he finally tempted death one time too many and was in a situation that I couldn't help him out of, I moved from New York, to Los Angeles, giving up my hard-won career in the fashion industry to be with him. I couldn't stop the inevitable, but I know he felt safer because I was there with him. He was my brother and my best friend. Michele Loud

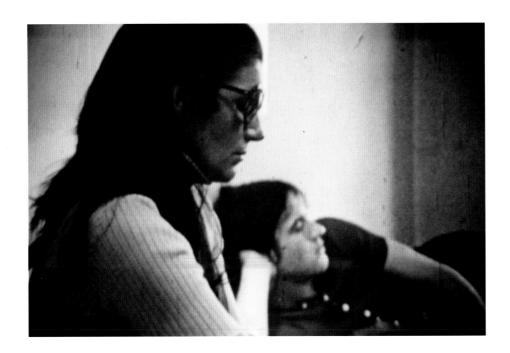

Bill Loud's plane en route to Korea,
with a DE-4 engine, shut down
over Johnson Island

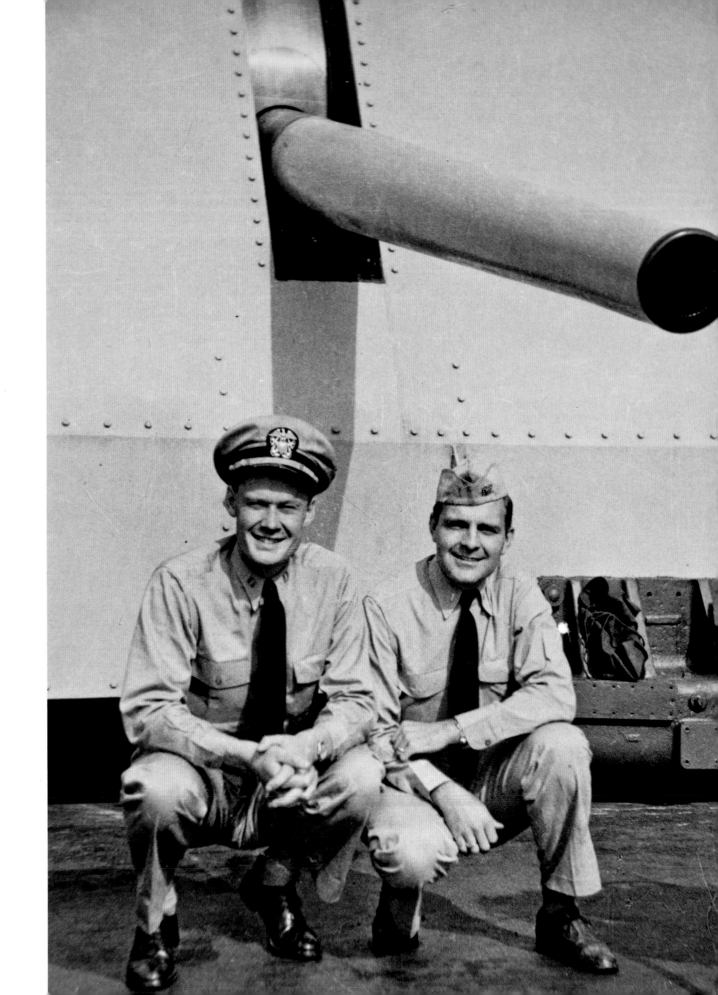

Bill Loud abord the James E. Kyes, DD747 with Ens Wes Radford, during the Korean War

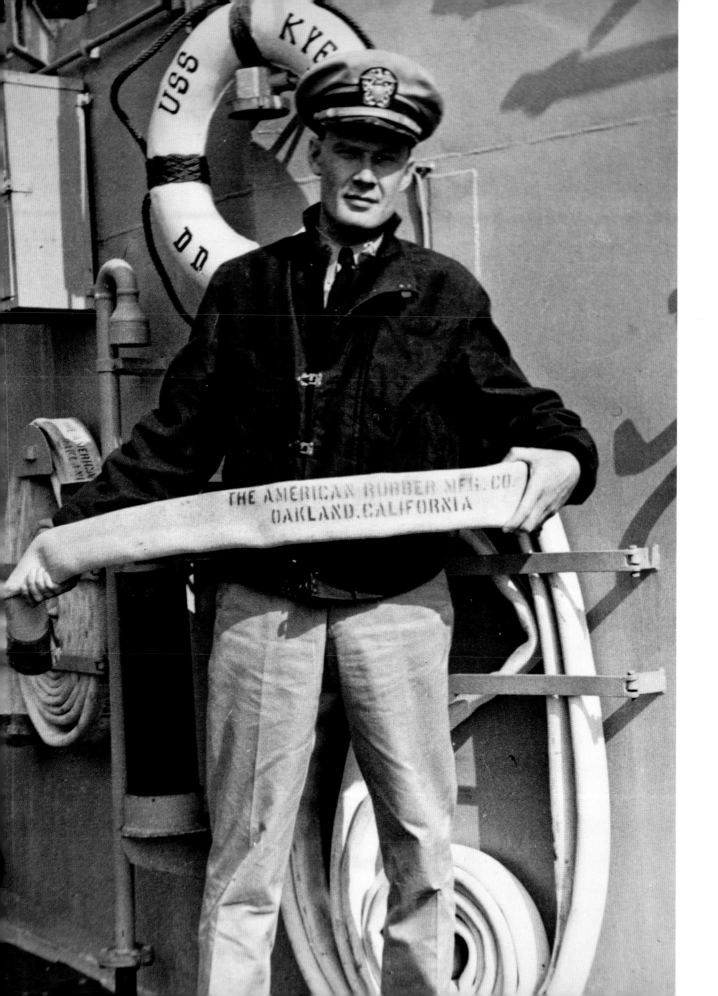

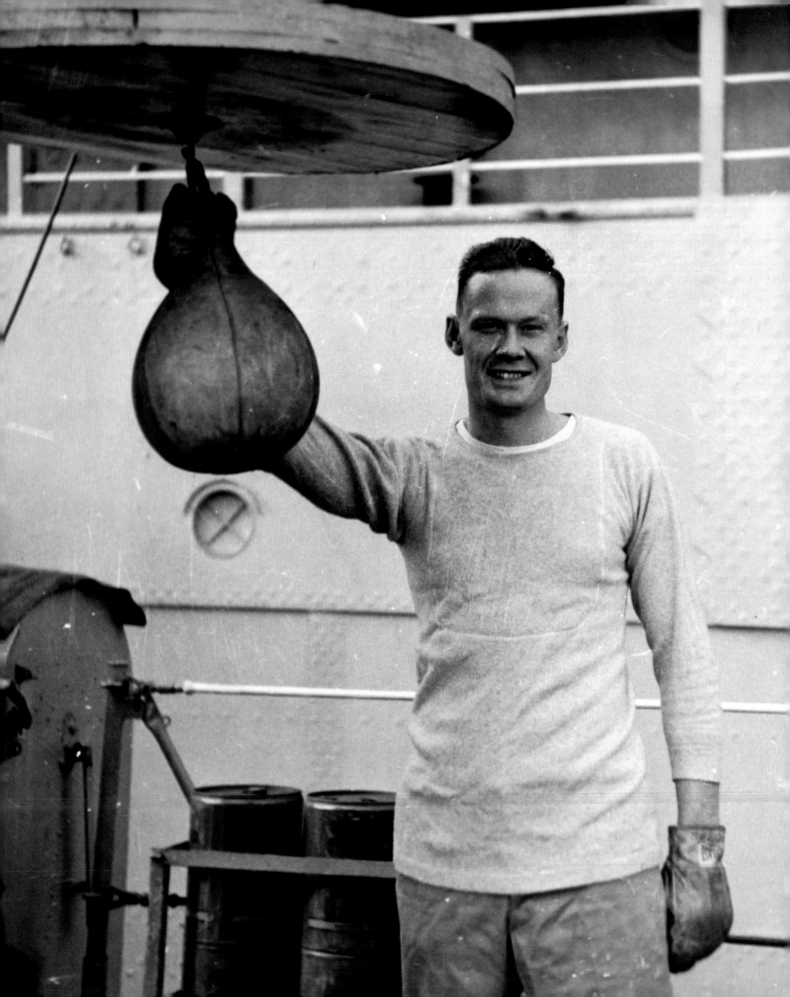

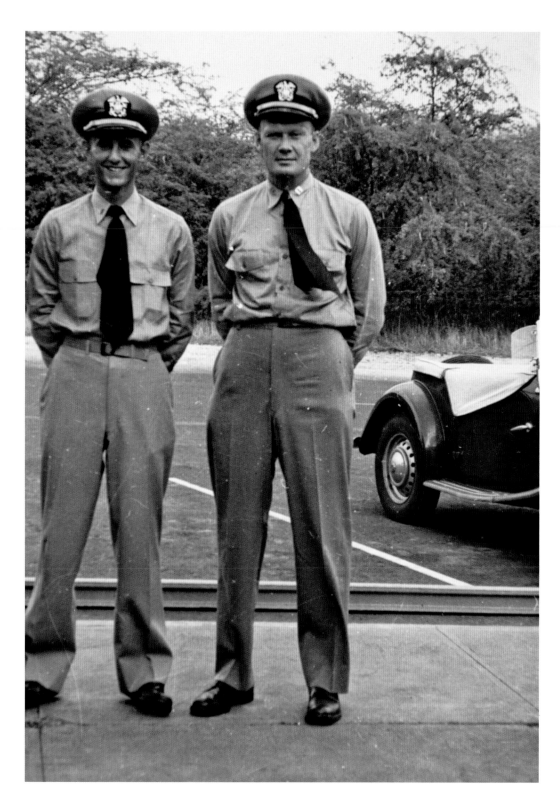

Honolulu, at the Nval Air Control
Training center where Bill Loud
prepared to go to Korea in 1951

Bill Loud with Lance, 1954

Pat Loud with Lance in Oregon, 1954

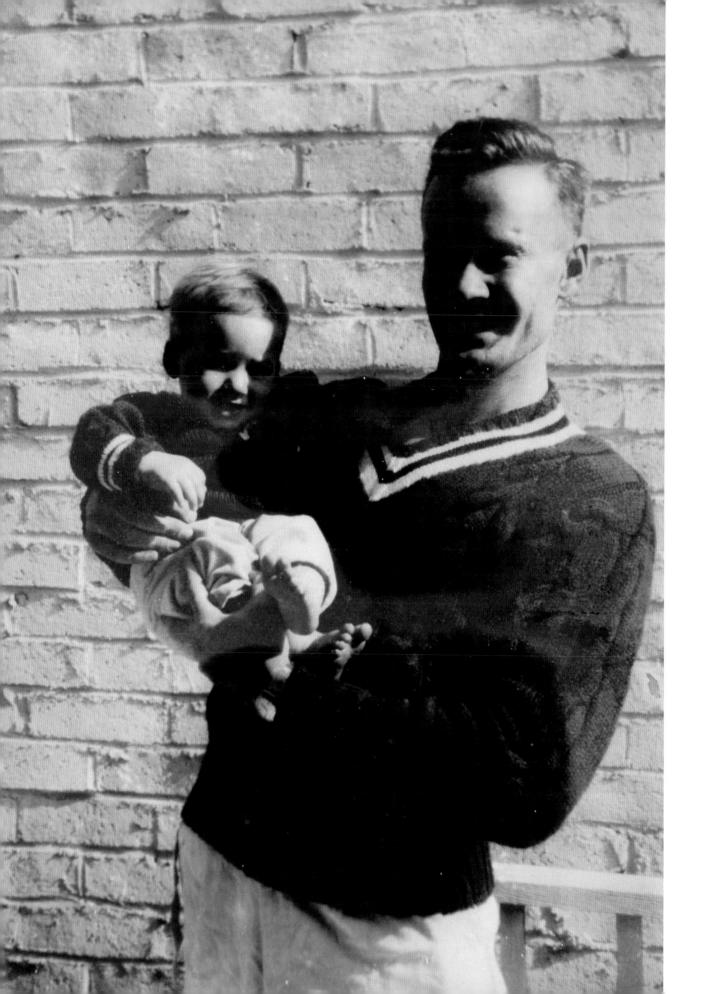

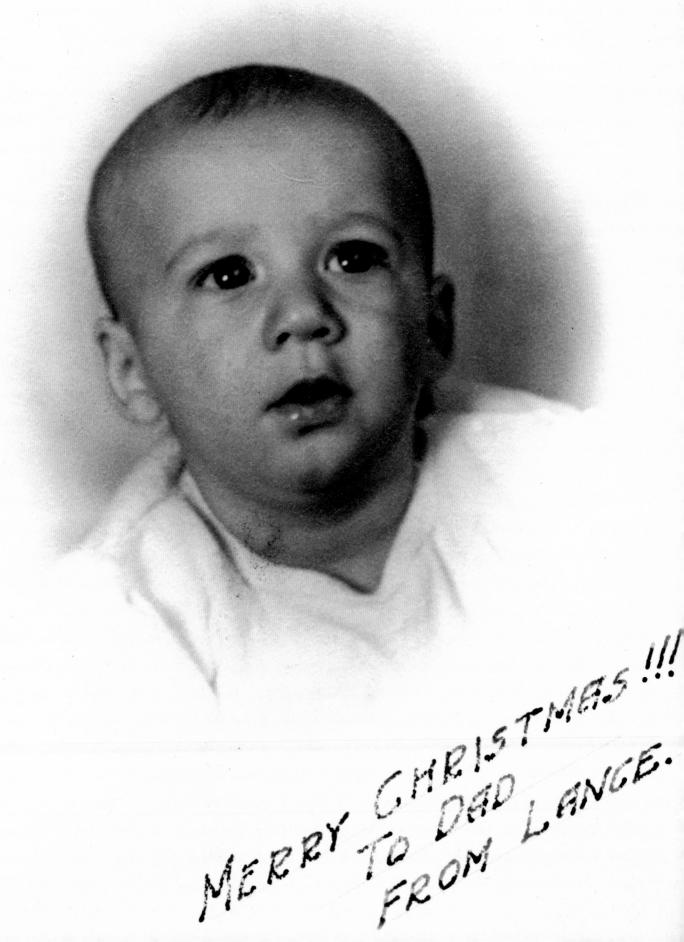

MERRY CHRISTMAS!!!
TO DAD
FROM LANCE.

Come to the Edge, He Said. Honestly, I'm sorry to drag my feet on this, but how do I go about putting into words a friendship that was fundamental to my life for oh-so-long, and was made up of numberless small moments, of conversations, of thrift stores and farmers markets and movies and parties and trips and motorcycle rides and county fairs?

But of all these, most important was that almost-daily phone call, "Hi, its Lance."

Lance was my go-to guy for help:

For going to the Hollywood Farmers Market at 9 a.m. on a Sunday for some "dee-licious" grapes.

For going to screenings of movies, some good, most horrifyingly bad, and we always ended up sitting right next to the publicist so we could not leave.

For those fabulous salons at your home on Fountain, where I met such amazing and talented people over your "dee-licious" home cooking.

When we went to the Pasadena Humane Society to get a kitten for him and when we went back to pick it up a few days later found out it had inadvertently been euthanized. I drove home silently while he cried.

All those trips to St. Vincent de Paul thrift store in search of elusive treasures.

That car trip to Palm Springs when the engine blew up, and he left it with a guy at a burrito stand to repair. He thought that made perfect sense. I had to take a bus home. Later he caused a massive traffic jam when it broke down en route back to LA.

Other trips out to the desert were more successful. We really did have fun, he loved the thrift stores in Indio, he found treasures there; black leather jackets for $5.

Driving up to Santa Cruz to help my son move into his first apartment, we had to stop at every small town thrift store from Oxnard to San Luis Obispo. We drove thru Santa Barbara and he showed me where he said he had flipped his dad's Jaguar XK-E and where he went to school, where his pals had lived—Kristian, JD. He loved his childhood, and knew deep down that he was always the Golden Boy. That was your gift, Pat. Your unconditional love and acceptance made him that confident risk-taker that ultimately he paid the price for. But that confidence also made him fearless about life, and he embraced it wholeheartedly.

Details magazine once flew us up to Las Vegas to interview RuPaul, who was in his heyday, a big shiny superstar. Lance strode up to him as if they were teammates on a Little League team. Lance treated everyone just like they were "just folks," and I was so often dumbstruck by his social skills. How does anyone get so comfortable in his own skin? Once he told me to meet him after work at an opening for some photo studio. I showed up in my scrubs; it was Smashbox.

Photogs took his picture on the red carpet. Parliament/George Clinton was playing, it was super-A list and Lance stood by me as we walked in—me in my nursing scrubs! Oh, Lancie! He showed me a loyalty and devotion I never have felt before or since. I am still so thankful.

My life is better having known him. I will never forget him. There will never be another like him. I shall love him forever.

"Come to the edge, he said. They said: We are afraid. Come to the edge, he said. They came. He pushed them and they flew." — Apollinaire

Lance was so much more than just Lance. He was a force of nature. Debbie Trent

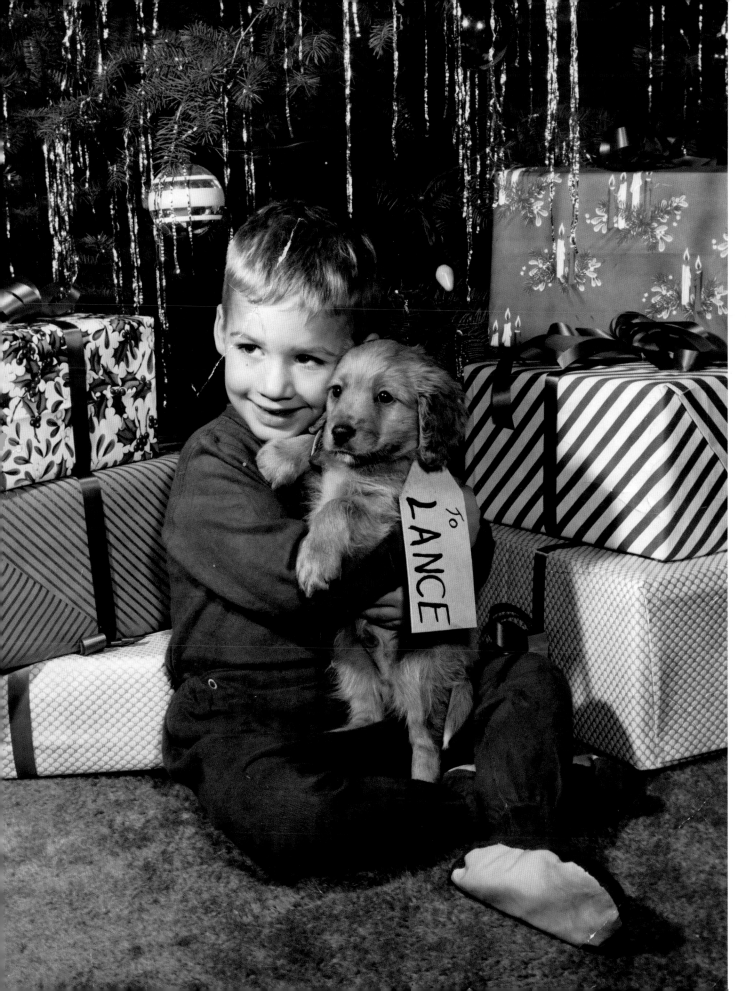

Lance and his Christmas pup featured on the Christmas day issue of the "Eugene Register-Guard," Oregon, 1956

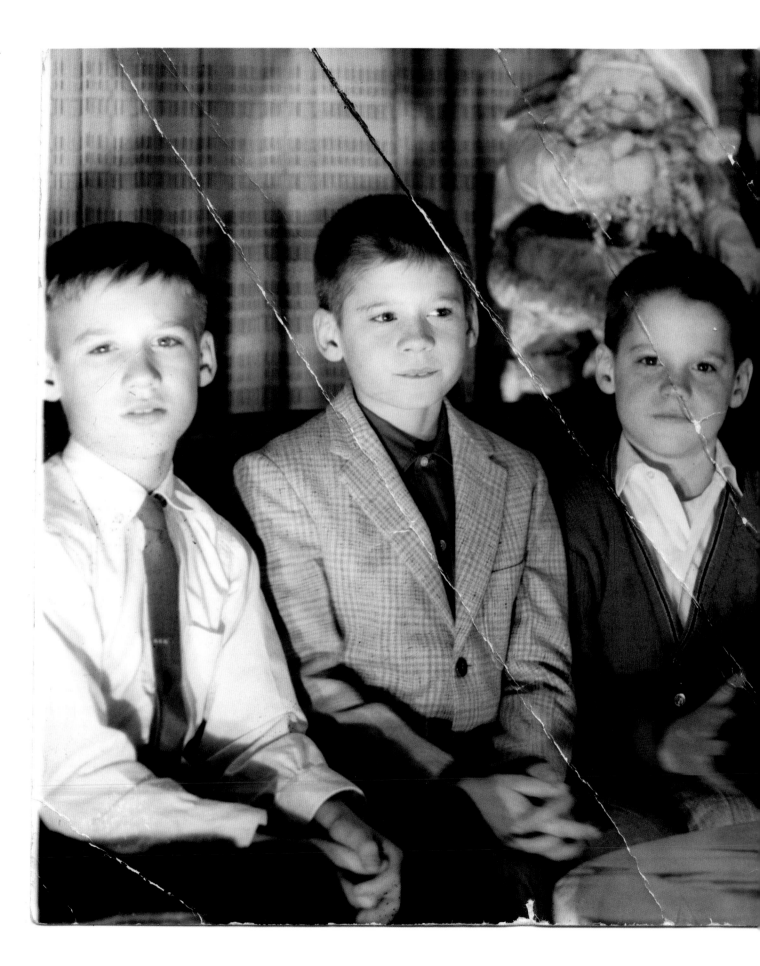

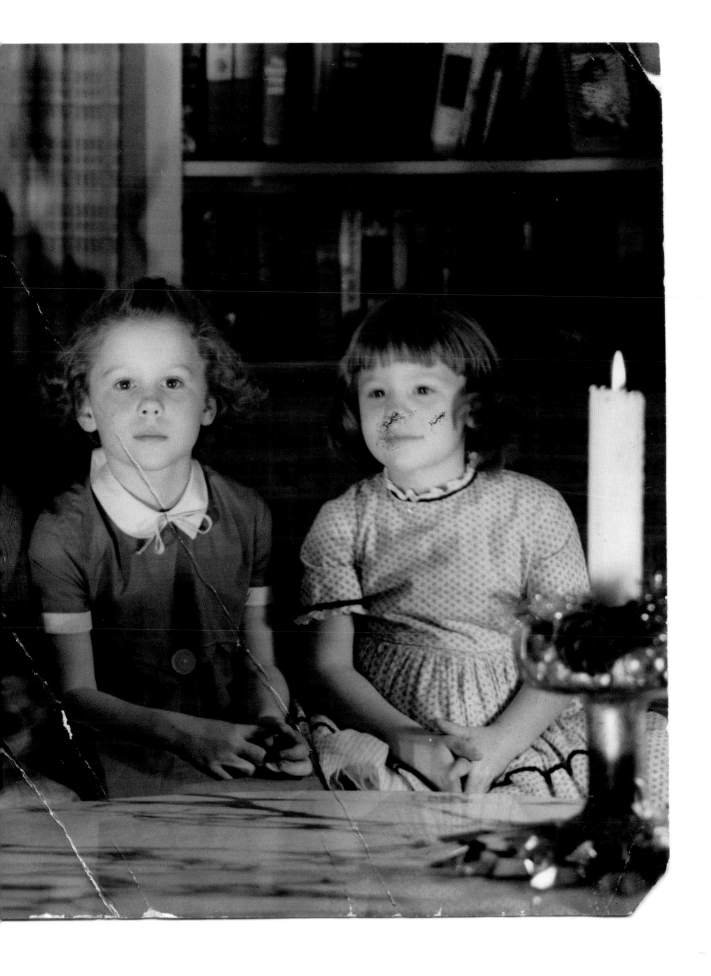

P228

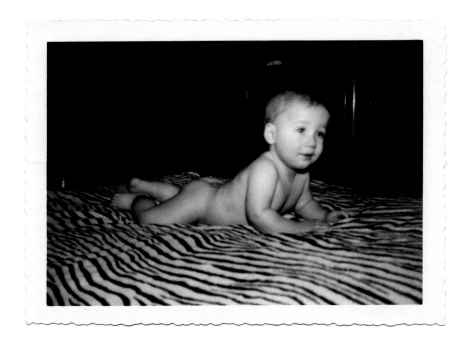

JUN • 55

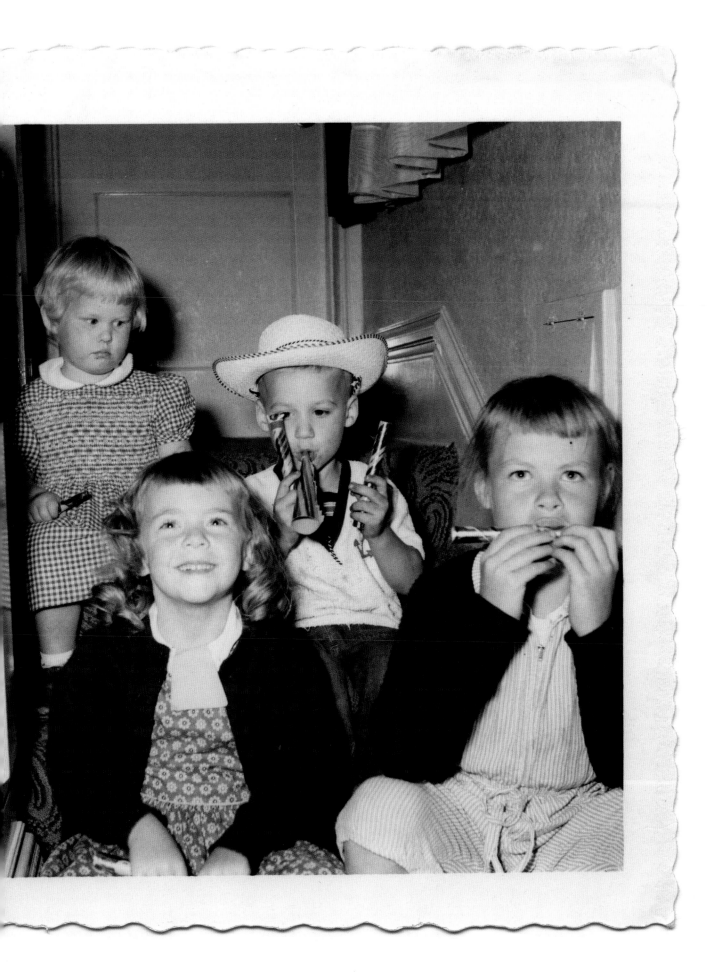

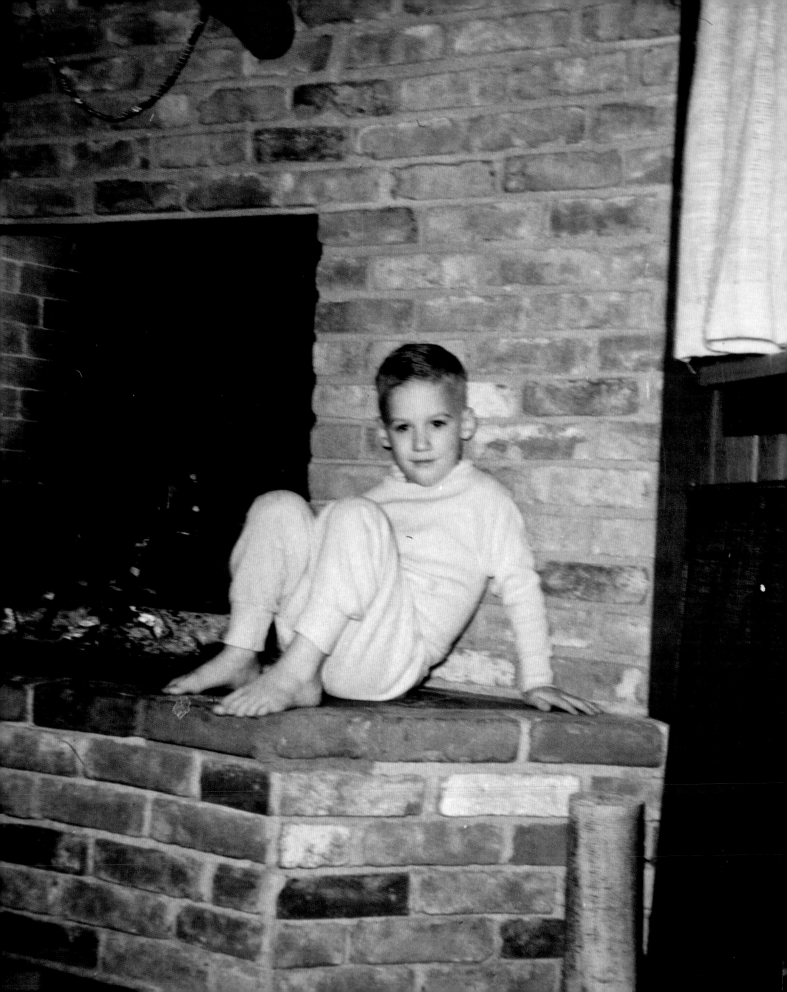

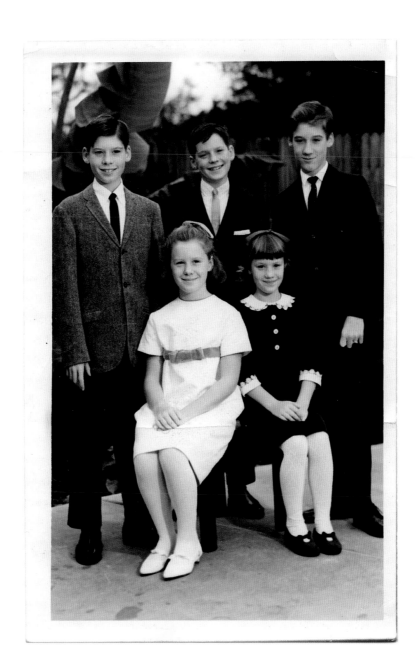

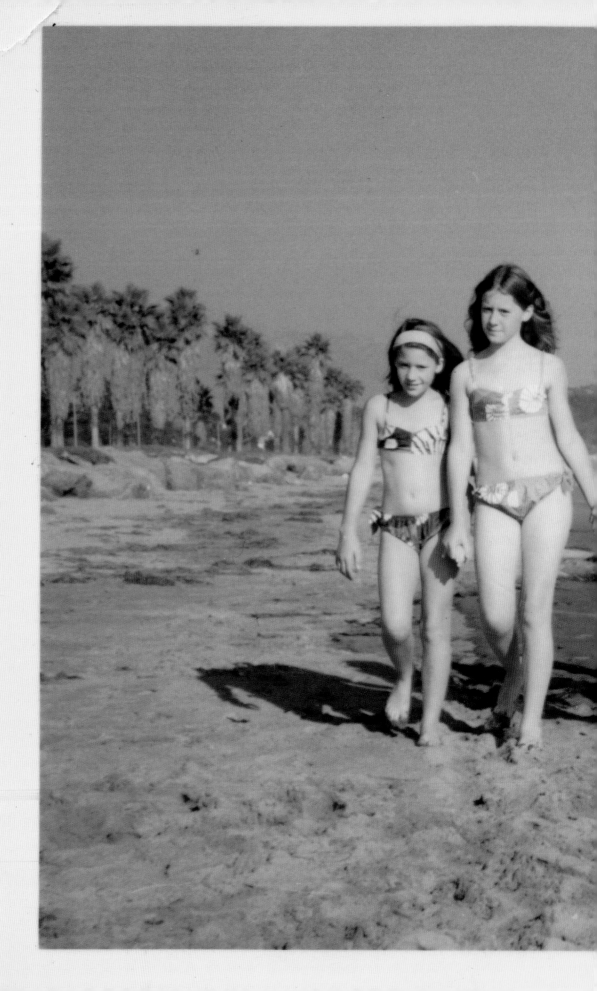

The Loud family en route to Calgary, Canada for a business trip with Bill, where a complete display of Stief stuffed animals were on display in the hotel lobby; Lance's favorites

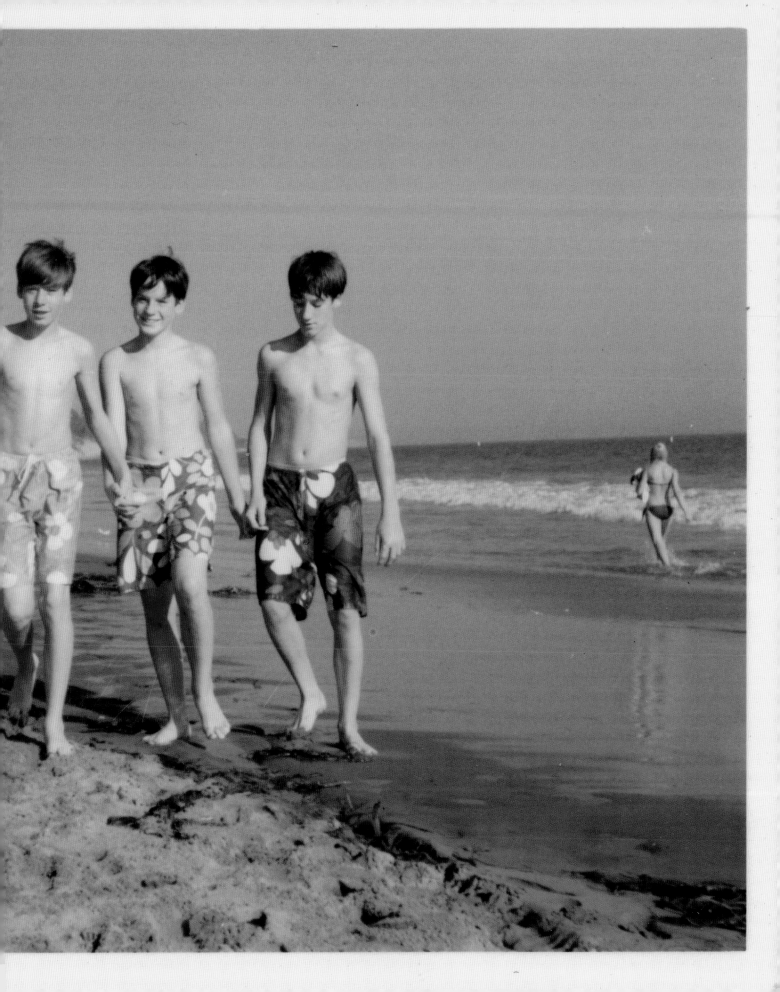

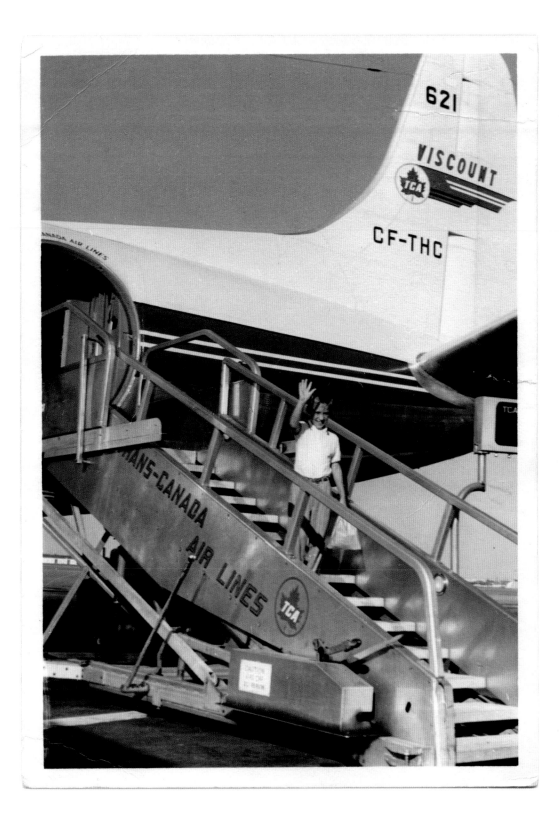

Eulogy, My Huckleberry Friend. After being close to Lance for 25 years, it is impossible to recount just one or two stories that I might share. Besides, we all have our "Lance" stories. If you knew Lance for five minutes you had one to tell.

Instead I'd like to share what might not immediately come to mind when we think of Lance and that was his incredible love of women. Lance and I would always laugh, thinking how husbands and lovers would come and go, but he was the only person macho enough to hang in there with me, for better or worse, when things got messy, ugly or just too real, and mere straight men would run for the hills, there was Lance. He loved and appreciated women in life, film, music, art and literature. No one I knew could groove harder to an obscure Aretha Franklin tear-jerker; to dance, grunt and strut with all the bravado that I of when I think of Lance.

No man, woman or beast, except Lance, would know exactly just how very cool Julie Christie was in *Darling* or *Petulia* and how he loved Ronnie Spector's teased beehive hair and exquisite eyeliner as she sang, "Be My Little Baby;" or savored film critic Janet Maslin crucifying a film as he enjoyed third and fourth helpings of his beloved mother's home cooking, which was always his favorite as he read the Sunday *New York Time*s. No one but Lance knew how to meticulously relish Anna Magnani flipping out on the telephone in a black slip and Giulietta Masina in anything always broke his beautiful heart.

Perhaps to the uncool or untrained eye, the rookie of life might think that was all there was to Lance: his charm, lust for life, enthusiasm and energy. He could overwhelm with his splash of circumstance. But all that passion came from a very deep place and eternally groovy pool, where you pay dues in spades and give yourself wholeheartedly to life. No matter whose heads rolled or how bad the neighborhood might be.

Lance is distinguished because he was a paradox, beautiful and ugly, superior and humble, a loner and social butterfly, ultra-private and a world-class gossip, an oozing, sweaty, romantic and bitter-acid realist, an avant-garde misfit, yet traditional in so many ways. He was lighthearted and free, yet deliciously melancholy and morbid—until that got boring, or the phone rang.

I believe only a person of paradox truly embodies the real essence of life with all its contradictions and complications. We all have them, of course, it's just that Lance would invite you in to share and bare his soul as he modeled his newest "fave" outfits—music blarin.' The picture that appeared in *The New York Times* magazine, where we are dancing wildly, says it all. I laugh, thinking how Lance would have laughed that our picture was huge when Ian Schrager and Steve Rubell's pictures looked like a footnote in an era they epitomized.

Lance loved a good laugh. I remember when Lance and I went to the dreaded Studio 54 once to attend Blondie's "Heart of Glass" party. We were late and did not go in the VIP door as instructed. We just went instead to the front door. When we got there the doorman stopped us and told us to wait. The crowd yelled out to Lance, "Tell him who you are! Tell them who you are!" But Lance didn't

budge and the now concerned doorman tried to stop us from leaving, yelling out, "Hey, wait, who are you?" Lance just beamed one of his fuck-you-Cheshire-cat grins and as we got into the cab to race back downtown, I heard someone say, "That was Lance Loud!"

No man I have ever known knew how to really appreciate what was good about a person and then go directly (in his red Beatle boots, clicking—like Dorothy) to the cool and rock, the very essence, like only Lance could. We did not have the perfect relationship and he was not perfect. We fought and wrestled with our conflictsl, swearing it would be the last time we met in battle and that he had really, really done it this time. But our problems were always were secondary to what was most important: sharing and celebrating life.

I know sometimes people would become frustrated, myself included, when Lance would not abide by this or that rule. However, you never had to nag Lance (he made you feel too cool for the role), because he was very hard on himself. I am sure he would think of himself as jaded and probably not too innocent. In spite of his scathing shelf-assessment I do not think he realized how innocent he truly was or how charming, either.

Before knowing Lance I thought that charm meant you were witty, smart, quick. Once I knew Lance, I could see that others would fall short of exhibiting the charm that was so effortless to Lance. I finally came to understand that Lance's inimitable charm, real charm, was about how he made the other people feel when they were around him. I am not sure that he realized what he really gave to us.

When others may have accused Lance of being a tad irresponsible, I felt it was just a mere technical glitch, because I felt Lance was responsible in the most fundamental way: Day by day, minute-by-minute, Lance took responsibility and took the bull by its rather significant horns, to rise to the occasion of life. And if he was ever intolerant, it was of people who would not do the same.

When Lance and I first met, we were talking about a mutual acquaintance who Lance did not like.

I asked him, "Why don't you like him? He seems nice."

He said, "Well, he's not and besides that he's committed the worst sin of all!"

I said, "What, what did he do?"

He said, "He's a fucking bore!!!"

That may sound mean-spirited or sarcastic, but Lance did not mean it that way. It was just that Lance expected people to rise up and take responsibility for making life grand. Lance never, ever took life for granted, and I am comforted to know that he always realized that life is short. He never missed a beat. I am thankful for every beautiful and horrible moment I had with Lance. Lance never took more than he gave and if anyone ever was worth the trouble it was Lance, my Huckleberry friend—the coolest guy on earth. Victoria Galves

Index

P240

See the videos. Scan with Smartphone.